ENDANGERED SPECIES

Other Books by Dierdre Luzwick

The Surrealist's Bible, by Jonathan David Publishing

Endangered Species

Portraits of a Dying Millennium

DIERDRE LUZWICK

FIRST EDITION

Library of Congress Cataloging-in-Publication Data

Luzwick, Dierdre.
 Endangered species : portraits of a dying millennium / Dierdre Luzwick. — 1st ed.
 p. cm.
 ISBN 0–06–250419–3. — ISBN 0–06–250420–7 (pbk.)
 1. Luzwick, Dierdre—Themes, motives. 2. Humans in art. 3. Social problems in art. I. Title.
NC139.L89A4 1992
741.973—dc20 91–55291
 CIP

Endangered Species *is dedicated to five people whose faith in this artist spared her from becoming one:*

Geene Gallagher Schultz—My Mother

Edward Schultz—My Father

Donald Ball—My Love

and

Clayton E. Carlson

Rabbi Alfred Kolatch—My Publishers

"May the wind be ever at your backs . . ."

Contents

Part III. Technology
The Dark Side of Science

Part IV. Alienation
The Destruction of Social Being

Foreword

In the early 1980s, when I was a curator at the Madison Art Center, the director and I set aside one day a month when artists could come in and show us their work. Some of the work we saw was truly dreadful, most was competent if uninspired, but on rare occasions there would be something so original and deeply felt that it would leave you somewhat bewildered—that is, it would challenge your ideas about what art could "do."

Dierdre Luzwick's work fell into the latter category. The work I first saw was from her *Christ-Kin* series: images based on New Testament events, but dislocated to contemporary, surrealist landscapes and peopled with famous historical figures or Luzwick's friends and acquaintances from around Cambridge, Wisconsin. It was obvious that the work was technically accomplished. Everything in her drawings was immediately recognizable, but the images were built up from abstract details whose mystery and complexity heightened the irreality of the whole scene.

But in the end technique was not what Luzwick's drawings were about; content was. And what was one to make of the subject matter? Though the work depicted religious subjects, it didn't seem conventionally religious. There was no hint of Christian proselytizing, but the spiritual relevance was real, even if it couldn't be defined. In every piece, one could sense an underlying humanitarianism and genuine concern for people's moral lives. It was as if those old Bible stories we heard as children were being retold in a way that made us reflect again about the difficulty of applying timeless ethical principles in a world that is infinitely more complex and morally challenging than we ever could have expected.

The drawings Luzwick has been working on over the past few years, the series *Endangered Species,* continues the humanitarian spirit of her earlier work, but in many respects this work is more directly critical of our human shortcomings—and is certainly far more disturbing. The difference between the two series can be compared to Michelangelo's Sistine Chapel frescoes. On the ceiling, he painted a sublime testament to the nobility of man that epitomized the High Renaissance. But on the altar wall, painted some twenty-five years later, an older

and more embittered Michelangelo gave us the *Last Judgment,* in which the optimism of the Renaissance gave way to a terrifying vision of justice and punishment for humanity's sins.

Four themes define *Endangered Species:* Ecology, Sexual Revolution, Technology, and Alienation. Within these topics, Luzwick has addressed the social, political, and environmental issues that threaten us, that make us an "endangered species." Subjects such as the greenhouse effect, deforestation, advanced weaponry, child abuse, AIDS, pornography, urban dehumanization, the plight of the elderly, and other problems are all chronicled with unrelenting effect.

These drawings do not catalog or illustrate these social ills, nor do they seem to promote a particular political or social agenda. We all already know and are concerned about the problems that are the subjects of these drawings. But these issues also make us uncomfortable and give rise to anxieties that we may readily repress so we can get on with our daily lives. The power of Luzwick's drawings is that they give form to the deep-seated feelings and fears that may have built up slowly over years of exposure to the facts and statistics we read in the paper or see on the evening news. Or we may have a more personal response: in many of these images, particularly those grouped in the sections Sexual Revolution and Alienation, we may recognize something from our own experience.

What is it that gives these works their powerful effect? An answer, first and foremost, can be found in their hallucinatory and dreamlike quality. As in a dream, some details are not well defined, whereas other portions are starkly realistic. And also as in dreams, the familiar is strangely juxtaposed with the unexpected. Exactly what is going on in any particular scene is never revealed outright; instead, everything seems permeated with symbolic implications the exact meaning of which we can't quite articulate. Of course, that is as it should be: symbols are powerful as long as they remain evocative and mysterious; if their meaning is too obvious, they quickly lose their interest and impact.

Nearly all the works are composed with a central figure or group that focuses our attention. Frequently, these are children or animals, who are portrayed either as innocent bystanders unaware of the dangers around them or as victims

of the particular situation in which they find themselves. These figures, perhaps more than anything else, are what give Luzwick's work its poignancy and sense of tragedy.

As you spend time with these drawings, you no doubt will find that the images possess some quality that stays with you long after you close the book. They continue to haunt you precisely because they are so visceral and intensely emotional. They force us to recognize that the global threats to humanity and the environment are not remote and abstract but affect everyone in a direct and personal way. These images also confront us with the realization that these conditions may be, in some small part, consequences of our own decisions. Thus aware, perhaps we will be moved to action.

Trent Myers
Former Curator, Madison Art Center, Wisconsin

Introduction

I can do nothing but admire the foreword by Trent Myers and what he has to say about Dierdre Luzwick's insight and her genius in portraying the diversity of nature and of humanity's attack on every creature's life-support system. I would agree that she is correct in pointing out that we ourselves are an endangered species and, worse than that, self-endangered.

Almost no one comes up with the number of endangered species I think we should be concerned with. That number needs to include, and be dominated by, the number of species of plants and animals that exist but have not been discovered and identified by humans. Taxonomists have dutifully catalogued about a million and a half species. Our knowledge about the origin of species, how they carry out their lives, and what they mean to each other and to us, is limited to but a miniscule part of that million and a half.

The number of species taxonomists haven't entered in their catalogues ranges, from what I have encountered in the statistics, from four and a half million to eighty million. Which means that we don't really know.

If we pick fifty million as a convenient round number and divide that by the number of species we are losing each year in the tropical rain forests, where half of them are presumed to be, and double that number to include the species we can reasonably assume we are disposing of elsewhere every year, we come up with a *loss of one species of plant or animal per minute.*

If, to be conservative, we cut the estimated fifty million species down to five million, then we would only be losing one every ten minutes. That conservatism makes me feel no better. I wouldn't like even one to be lost per year through act of nature; none should be dispatched by our hand. It is our hand, unfortunately, that is making the elimination so unforgiveable.

After all, extinction is forever. Some miracle of chemistry, synergy, and life that each species represents, each with its own errand, whether we know it or not, will not be back again if we sever it from the flow of wildness within it. That should mean something to our own self-interest if we believe that what serves us, however indirectly, should also interest us. Pharmaceutical companies

search assiduously for the medicines our indigenous ancestors may have known about and used.

We remember, when we take aspirin, that its origin was the wild willow. Jay Hair, president of the National Wildlife Foundation, is well aware of another origin. Some time ago he received the bad news that his infant daughter had but four days to live. That she is now in her college years he attributes to a leukemia-controlling miracle derived from the rosy periwinkle. That species existed only in Madagascar and is now extinct. Who would want desperately to need that cure and find that humankind had wiped it out?

Noel Brown, representing the United Nations Environment Program in North America, told a student audience in Colorado in October 1991, "We may already have destroyed the cure for AIDS." We may indeed have done just that. How would we know?

The possibility of such a lost human opportunity should motivate a new determination on the part of humanity, a determination to preserve the places that contain the genetic miracles we have yet to discover. We need also to be thinking beyond that—of the value of this genetic diversity not only to us, but also to each of its other peers.

We know of no other body in all the heavens that can boast the existence of life on it. Kenneth Brower, in his 1965 foreword to the Sierra Club's *Galapagos: The Flow of Wildness*, put the point beautifully: "A living planet is a rare thing, perhaps the rarest in the universe, and a very tenuous experiment at best. We need all the company we can get on our unlikely journey."

It is well to remember that other species, those that arrived in the eons the Earth knew without knowing us, are the innocent ones, and do not deserve to be prey to whatever wanton carelessness we choose to practice for our profit at their expense.

These innocent examples of creation, these vastly senior witnesses to what the life force has mysteriously produced, cannot vote for themselves. But henceforth *we*, knowing full well how they *would* vote, can cast a ballot for them.

We should *all* rally around and do whatever we can to *end* the endangering. I would like to see the next edition of this book contain a sheet of stickers for us to peel off and place on every mirror we own, saying YOU ARE NOW LOOKING AT A SELF-ENDANGERED SPECIES. In other words—and I can't emphasize this enough—we must remember that what we do unto others we do unto ourselves.

But to how many others, and at what cost?

David R. Brower
Founder, Earth Island Institute

Preface

They made love as though they were . . . an endangered species.
Peter De Vries

When I was a child, the world was just becoming aware of certain shortages. Over the cages of pandas, eagles, and gorillas hung quiet signs that read:

ENDANGERED SPECIES

This label signified that something unique—and precious—was passing from our planet into the cuneiform of legends.

Forty years later, the competent hands of ubiquitous authorities are composing similar signs for our own kind. Between the smoking trails where the Human Race has run lies a wasteland of nonrenewable highways. Over this silent desert hangs yet another sign:

DEAD END

This book is a collection of charcoal portraits depicting the diverse spectrum of threats leveled against our species at the close of the millennium. They are the hard bits and pieces of a Foreboding that extends far beyond the current alarm over ecological issues. Everyone agrees we have botched our bid for comfort by unleashing a technology that has created graver problems than it has resolved. What few attest to is that Environmental Apocalypse is not the result of faulty science—but of flawed technicians.

We are this planet's quintessential Manipulators. We have not only shoved Mother Nature and her living family around but also our own kind. With the arrogance of sociopaths, we have—as nations, lovers, parents, and prophets—bullied and used everything beneath the sun that we attained power over. Our "usership complex" is reflected as well in today's wholesale slaughter of the trees—from whose Life we create soft tissues to wipe our bottoms—and in the massive manifestation of violent pornography, rapes, and battering visited by Man upon his primordial property—Woman.

There is a catatonic by-product of habitual manipulation: emotional anesthesia. We are becoming catastrophically "indifferent" users. Today, we mate fast—and part faster; beat each other, and then our kids; dump God, toxic waste, and the elderly into one multilateral landfill; carve up animals; and, with scientific detachment, create unthinkable weapons. We do not weep over daily morning papers; we do not wail at the networks' evening news.

If the end of the world is at hand, it is parading forward on all frontiers of modern life before an impassive audience. Even our cheerleaders have specialized "rahs." Activist groups—each passionately involved with their own crusades—often appear apathetic toward the causes of others.

When animal welfare activists will not put up their dukes for the rights of gays or blacks; when an ecologist rages at the "pornography" of global pollution but fails to decry the exploitation of children on film; when health care specialists vie for credibility, not cures; and when feminists wrest "autonomy" at the expense of the family—then today's most ardent champions of "progressive evolution" are without vision.

Caring is either a total sum, incorporating all of life—or it is a divisive fraction.

We are devolving.

Endangered Species is a warning created by an American artist for a Western audience. The testing ground for a viable future will be the home of this planet's most efficient manipulators, extravagant consumers, and phlegmatic skeptics. As the earth's privileged Elite, we will either shape a just future or be shattered by injustice.

Those of us who have been comfortable and happy have purchased complacency with the "credit" of Preferred Ignorance, and many evils have encroached on our planet in this century, gaining permission through our passivity and establishing a kingdom of Darkness not easily routed.

Ecologists are fond of quoting Garrett DeBell's expression "There is a planet . . . who needs your help!" This bumper-sticker pleasantry has mistaken the identity of the victim. Earth is a tough old planet and has an appreciable life span

in which to lick her wounds. She will probably survive whatever we do to her in our passion for destruction. It is *WE* who are the frail ones—Man has become the prey of his own abuse.

We are becoming something less than we have ever been—aliens to each other and adversaries to Creation's creatures. On a poisoned planet, Man limps as the modern cripple, who—threatened by revocation of a biological lease—*still* refuses to acknowledge his jeopardy. The greatest obstacle to survival is always denial of disease. Bravado seeks no cure. Neither do the dead. . . .

Over our heads hang the quiet signs. And when we have read them, shall we make love—as though we were an endangered species? It may be the only alternative humanity has to not becoming one.

D. L.

ENDANGERED SPECIES

Part I

ECOLOGY

The Assault upon the Ecosphere

Ecology

Someday I would like to stand on the moon
. . . and say . . .
There certainly is a beautiful earth out
tonight!

Lt. Col. William H. Rankin

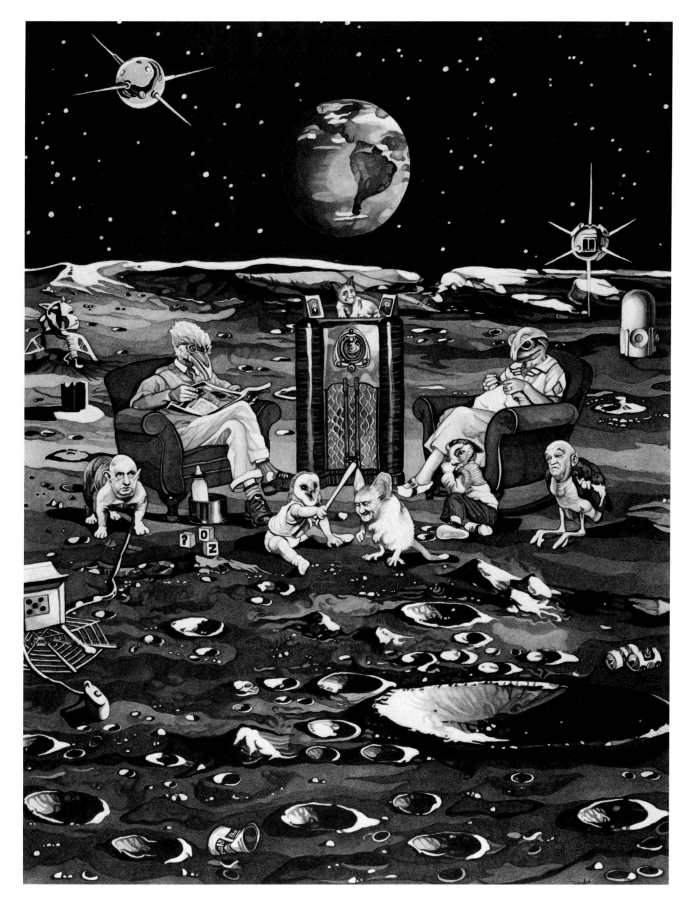

Primitives

Deforestation

When the trees die,
then the humans are next.

Old Native American
Prophecy

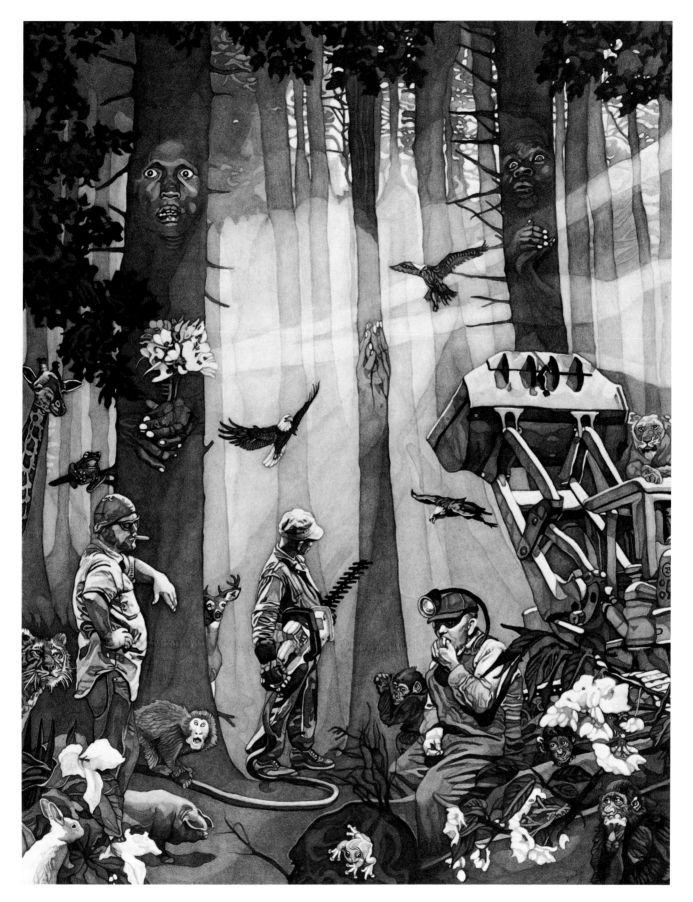

Water Pollution

I sometimes think that God
—in creating man—
somewhat overestimated His ability.

Oscar Wilde

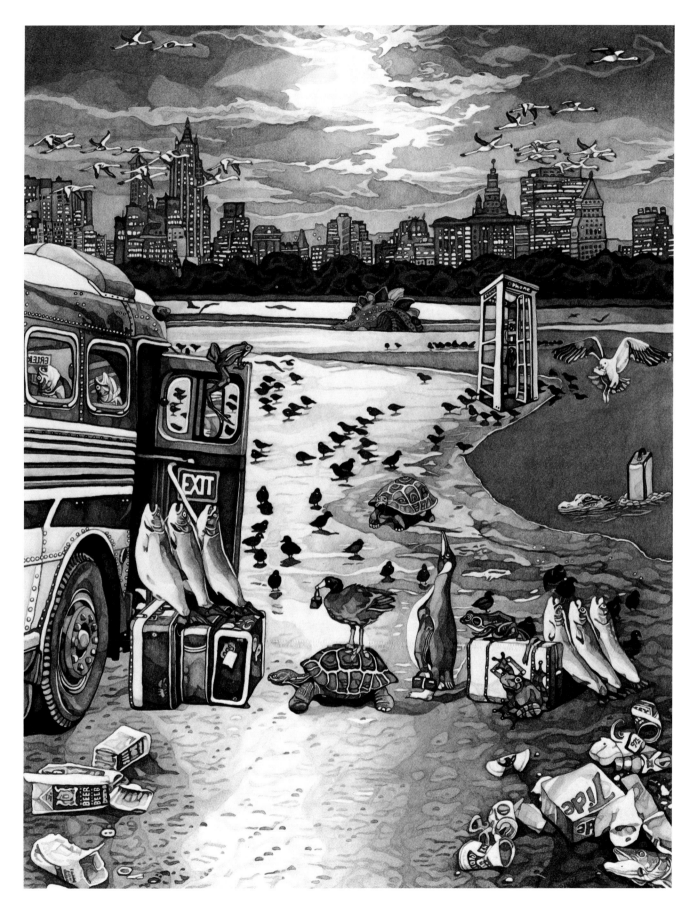

Eviction

Degradation of the Soil

*Everywhere the White Man has touched
the earth, it is sore.*

Old Wintu Indian Woman

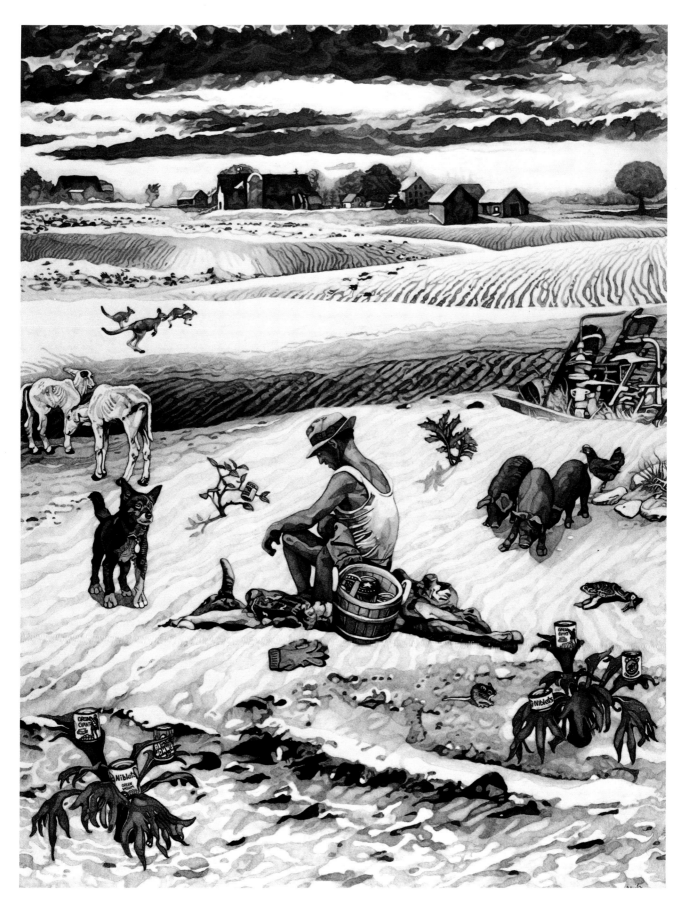

Harvest

Waste Disposal

A pig is beautiful
to a pig.

John Ray

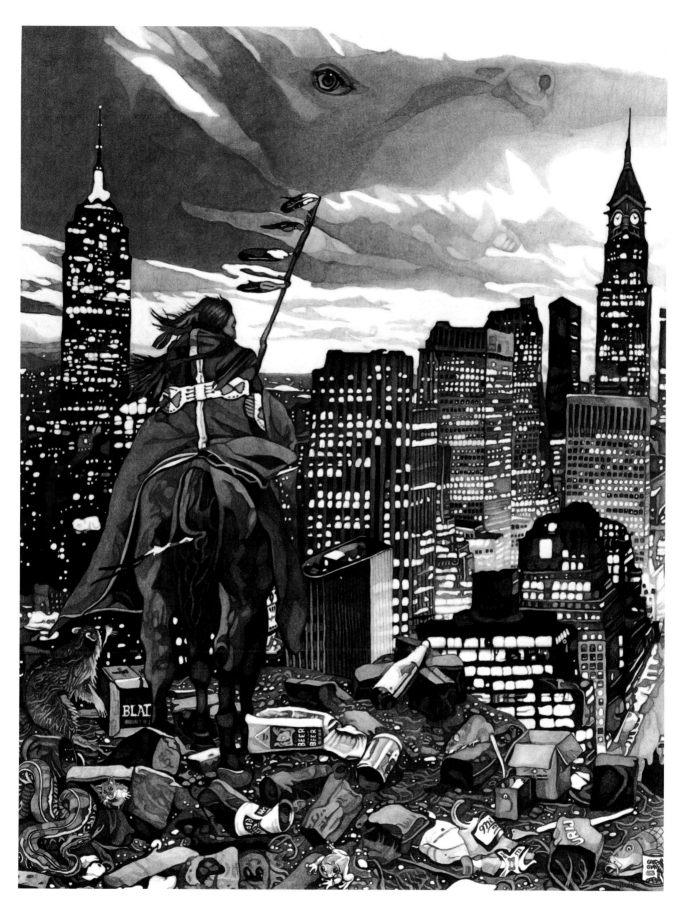

The Hunt

Atmospheric Pollution

*Civilization is a race between
education and catastrophe.*

H. G. Wells

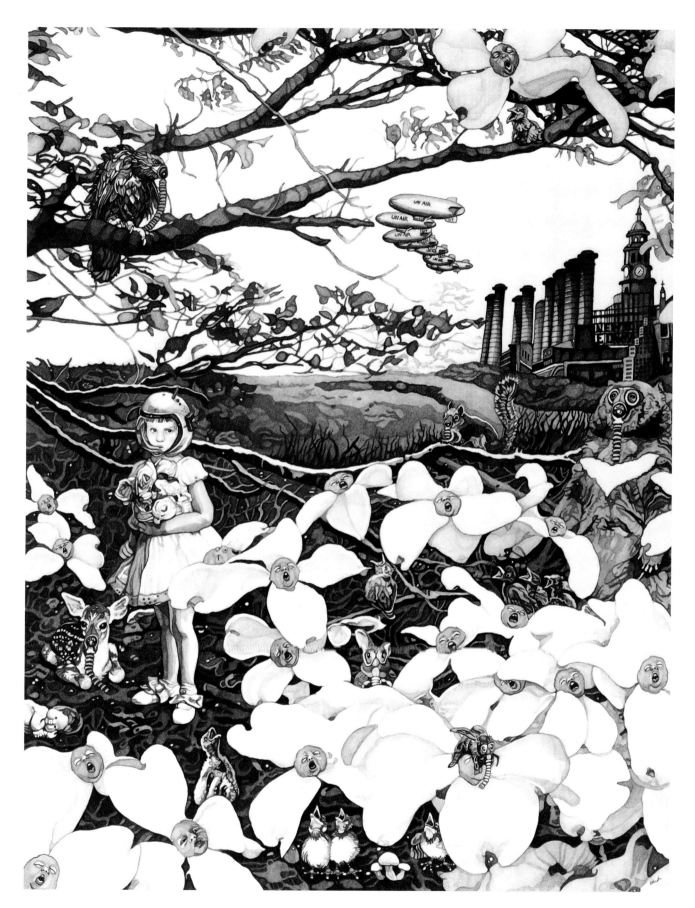

Air

Vanishing Wilderness

The wild places are where we began.
When they end—so do we.

<div align="right">David Brower</div>

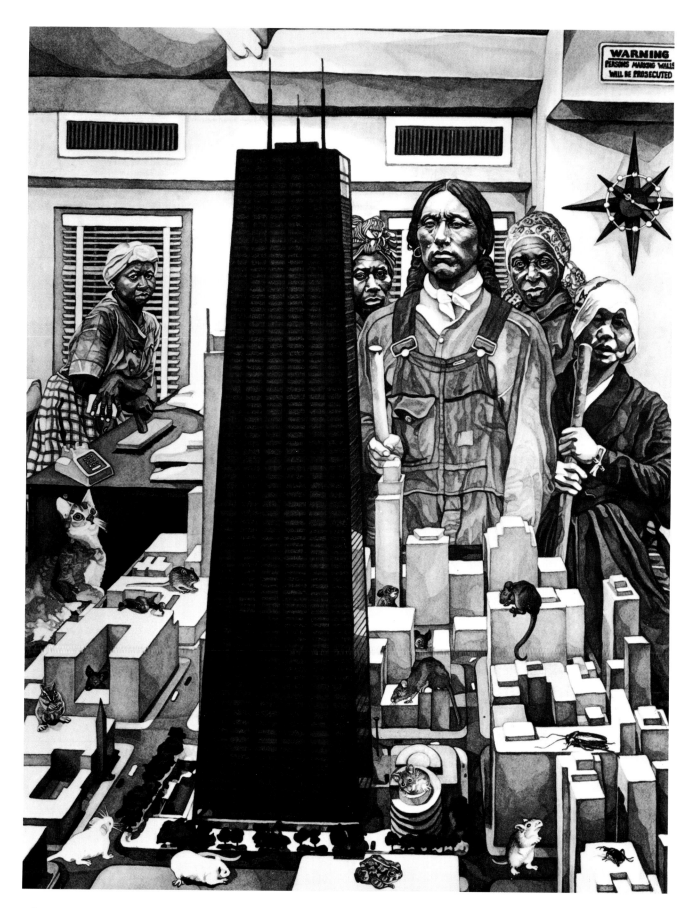

Cleaners

Overpopulation

Having discovered an illness, it's not terribly useful to prescribe death as a cure.

Senator George McGovern

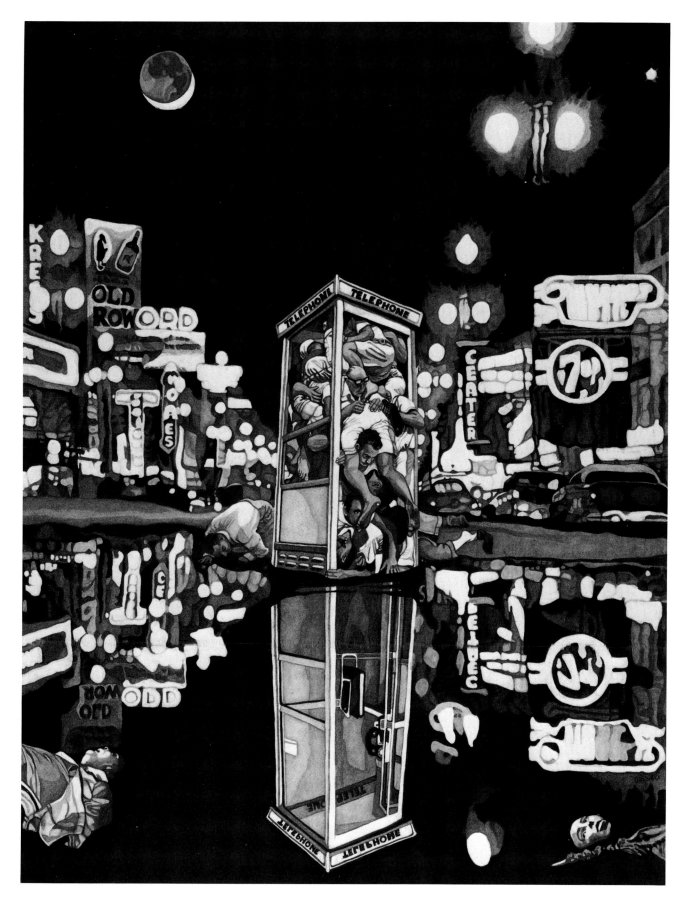

Wrong Number

Greenhouse Effect

What is the use of a house—
if you haven't a tolerable planet to put it on?

Henry David Thoreau

The Riddle

Animal Rights/Hunting

Whatever happens to the beasts
also happens to man.

Chief Seattle

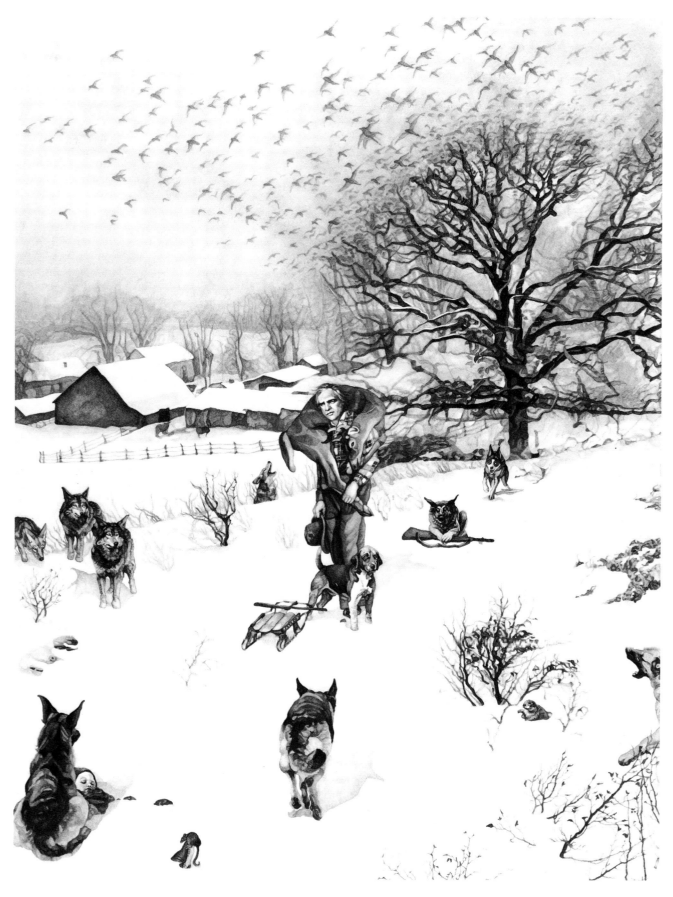

Animal Rights/Research

I don't think much of a man's religion
if it makes no difference to how he treats his dog.

Abraham Lincoln

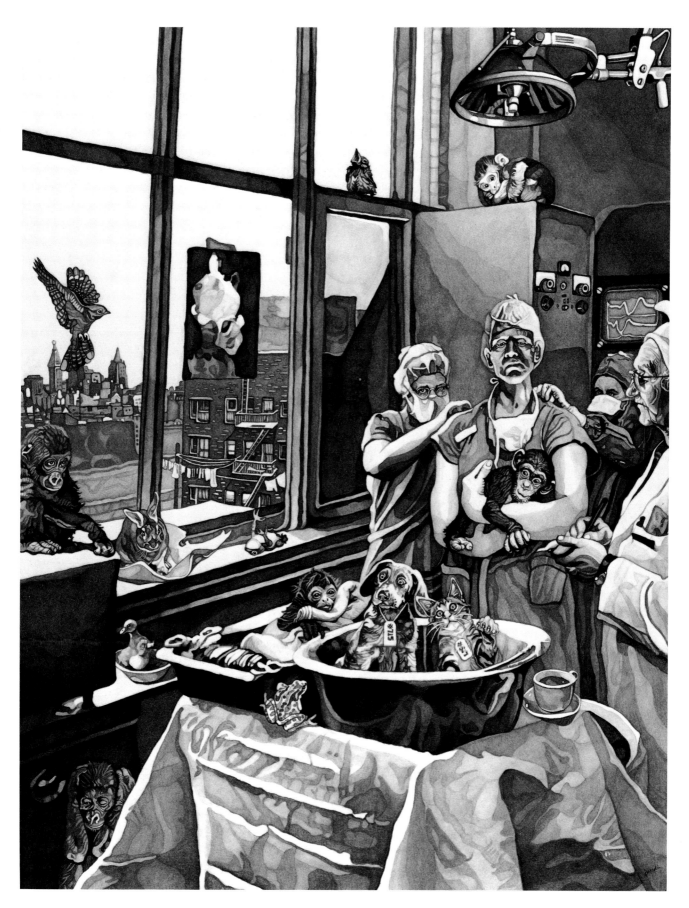

Animal Rights/Food

If modern civilized man had to kill the animals he eats, the number of vegetarians would rise astronomically.

Christian Morgenstern

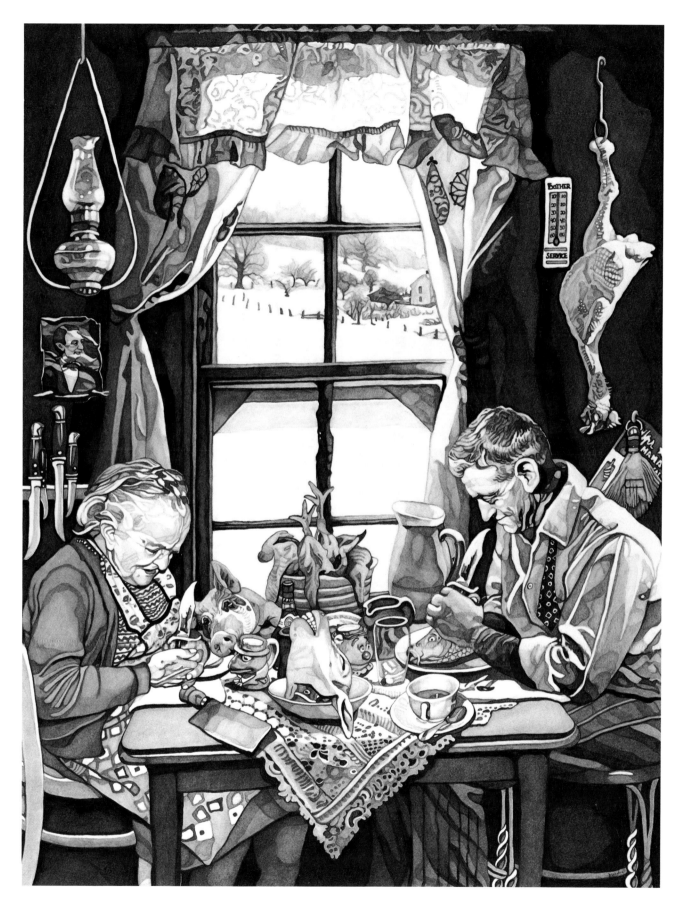

Meat

Part II

SEXUAL REVOLUTION

The Dissolution of the Family

Sexual Revolution

The real theatre of the sex war
is the domestic hearth.

Germaine Greer

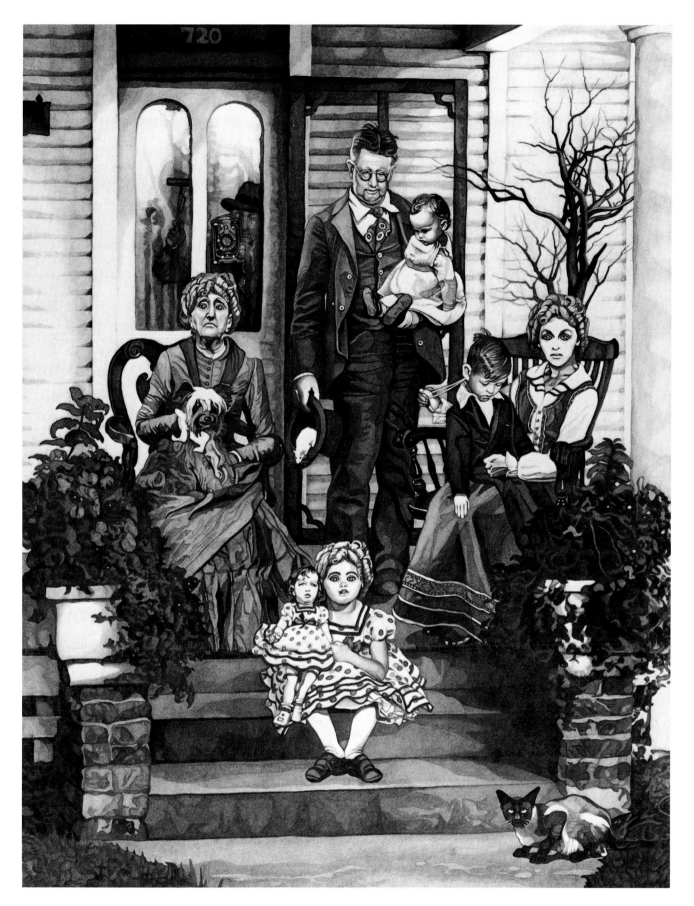

Queens

Women's Liberation

Despite my thirty years of research into the feminine soul, I have not yet been able to answer . . . the great question that has never been answered: WHAT DOES A WOMAN WANT?

<div align="right">

Sigmund Freud

</div>

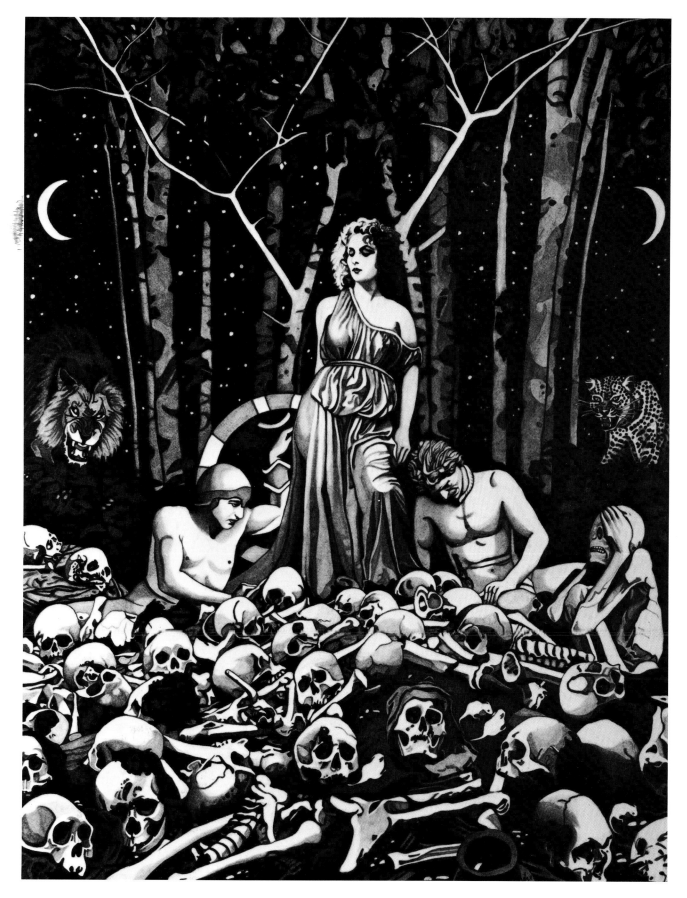

La Belle Dame Sans Merci

Matrimony

God, for two people to be able to live
together—for the rest of their lives—
is almost unnatural.

Jane Fonda

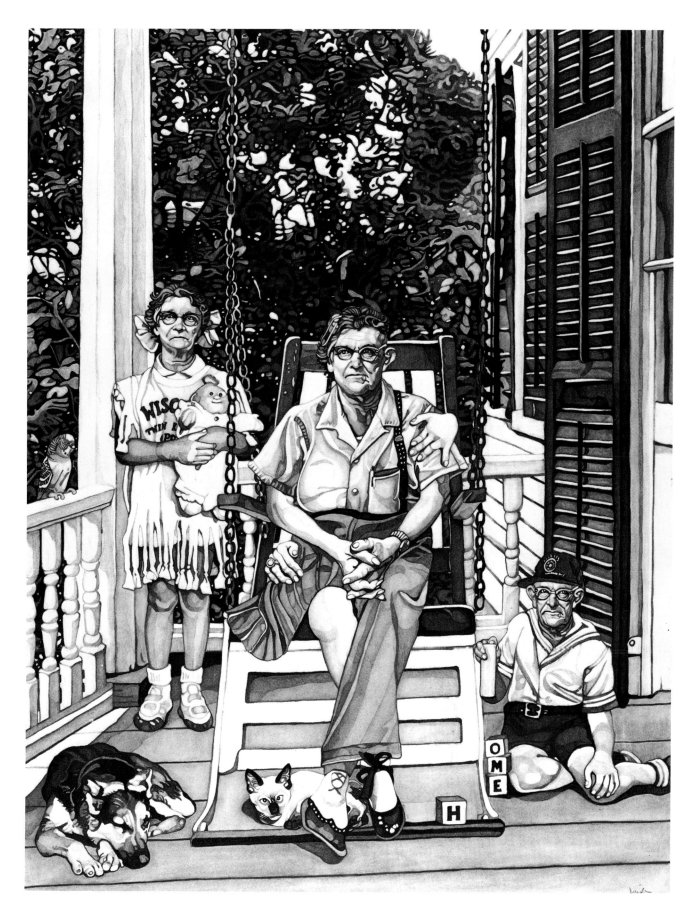

Married

Divorce

All marriages are happy.
It's the living together afterwards
that causes all the trouble.

Raymond Hull

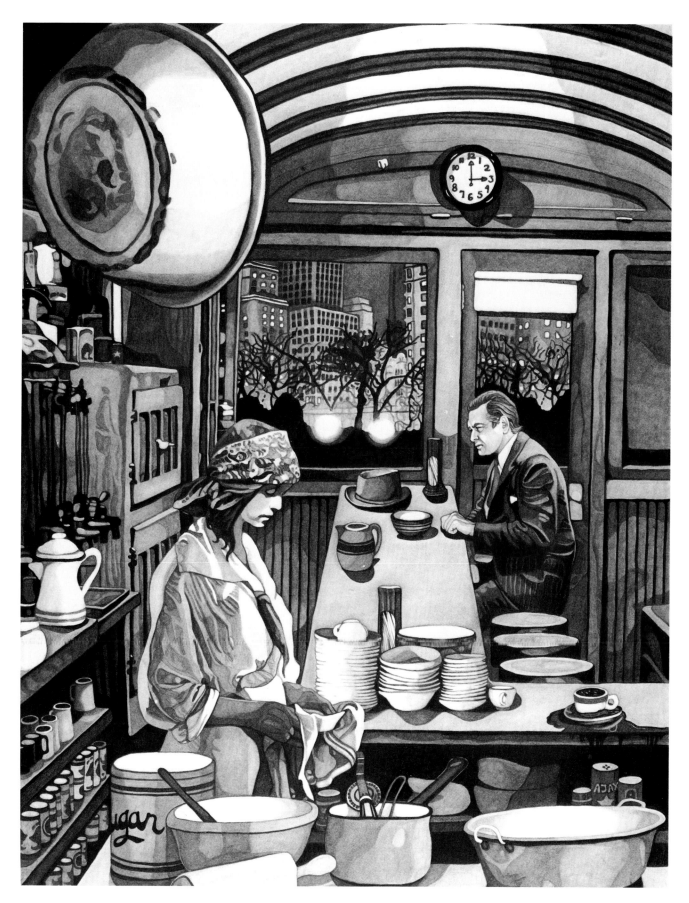

Acquainted with the Night

Working Moms

As long as the family, and the myth of the family, have not been destroyed, women will still be oppressed.

Simone de Beauvoir

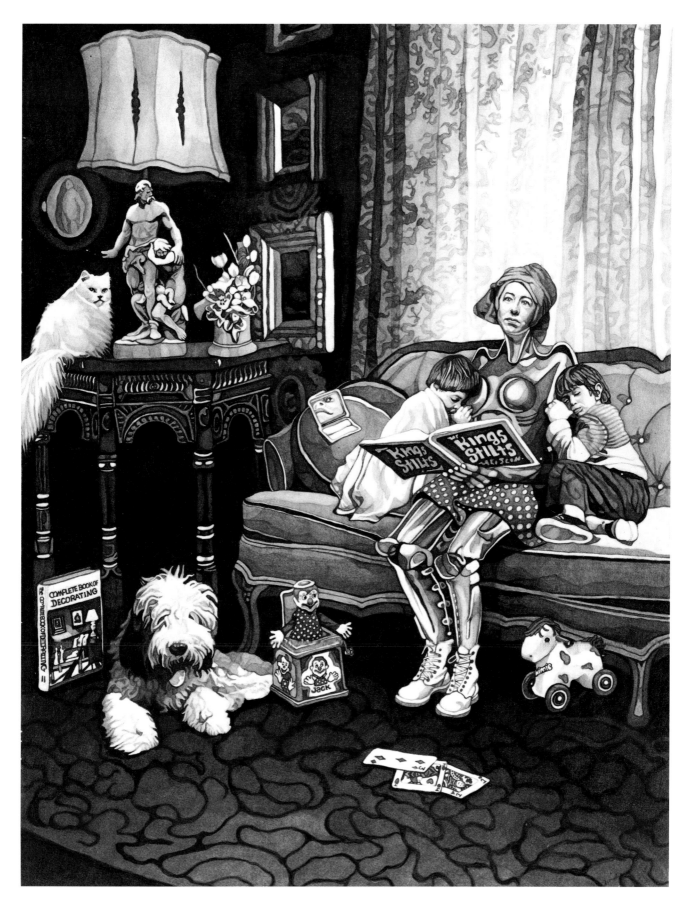

Mother

Casual Sex

Freud found sex an outcast in the outhouse,
and left it in the living room—
an honored guest.

W. Beran Wolfe

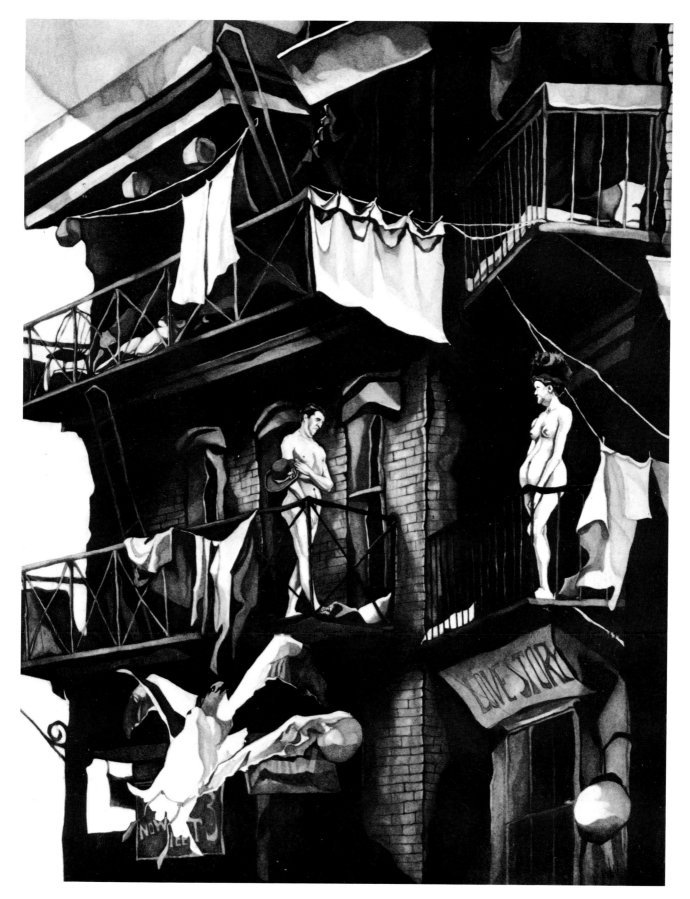

Love Story

Solo Parenting

Life is what happens to us
while we are making other plans.

Thomas La Mance

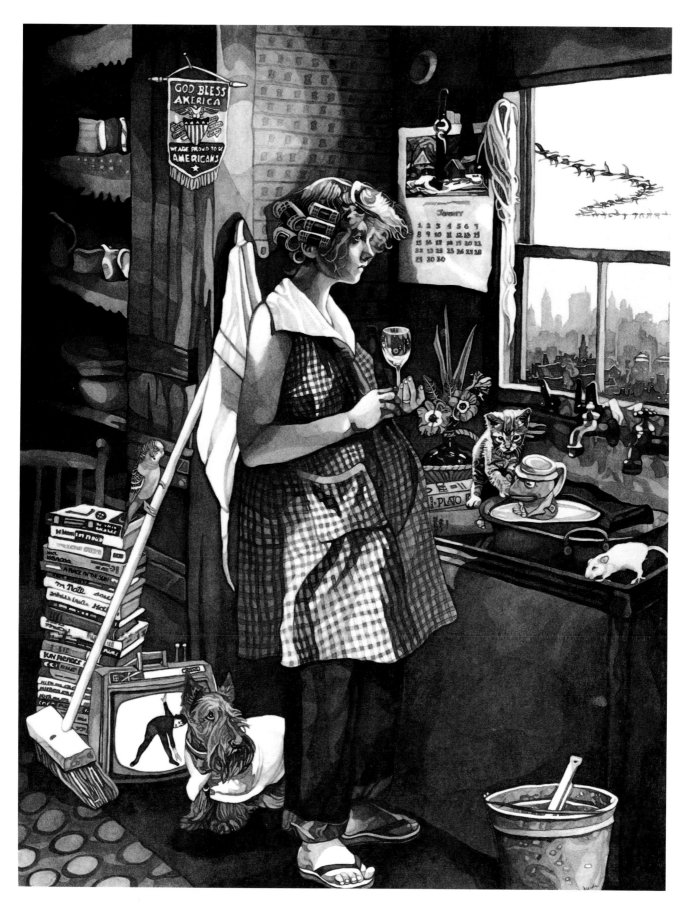

Singles

Abortion

Children are our most valuable natural resource.

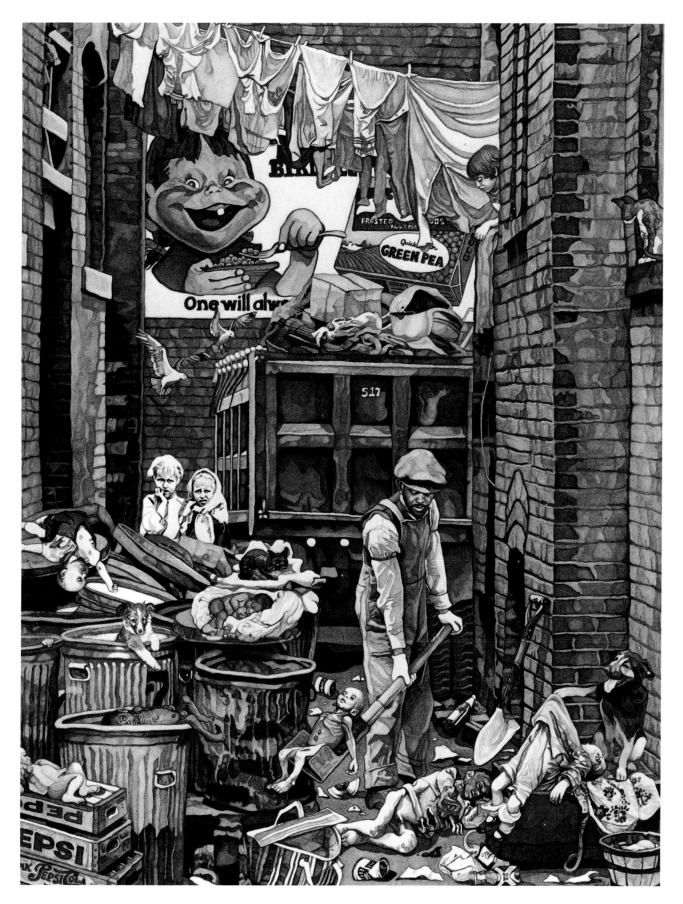

Trash

Child Abuse

There are no illegitimate children—
only illegitimate parents.

Judge Leon R. Yankwich

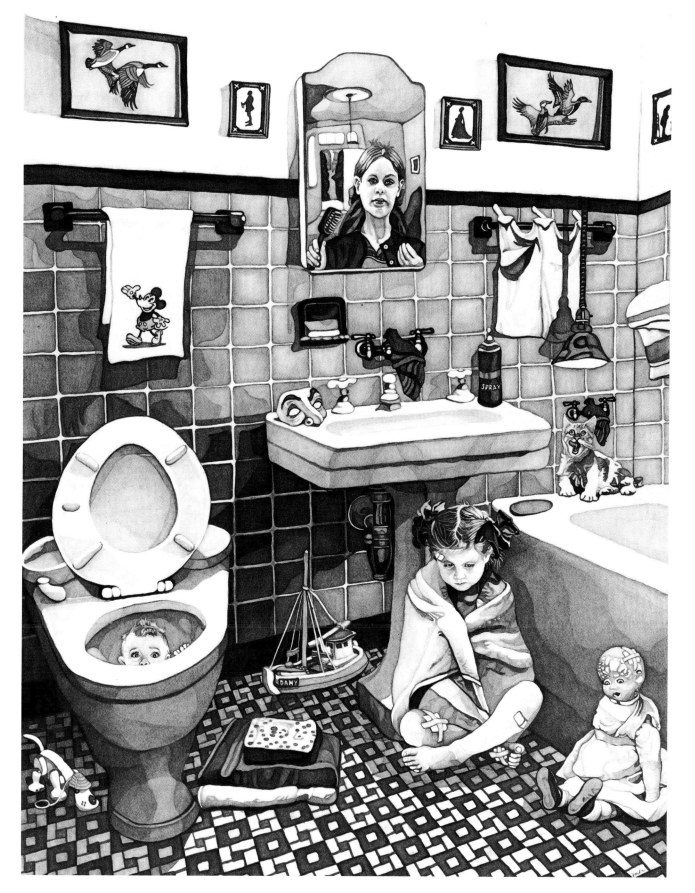

Bad

Sexual Abuse

The belief in a supernatural source of evil
is not necessary;
men alone are quite capable of every
wickedness.

Joseph Conrad

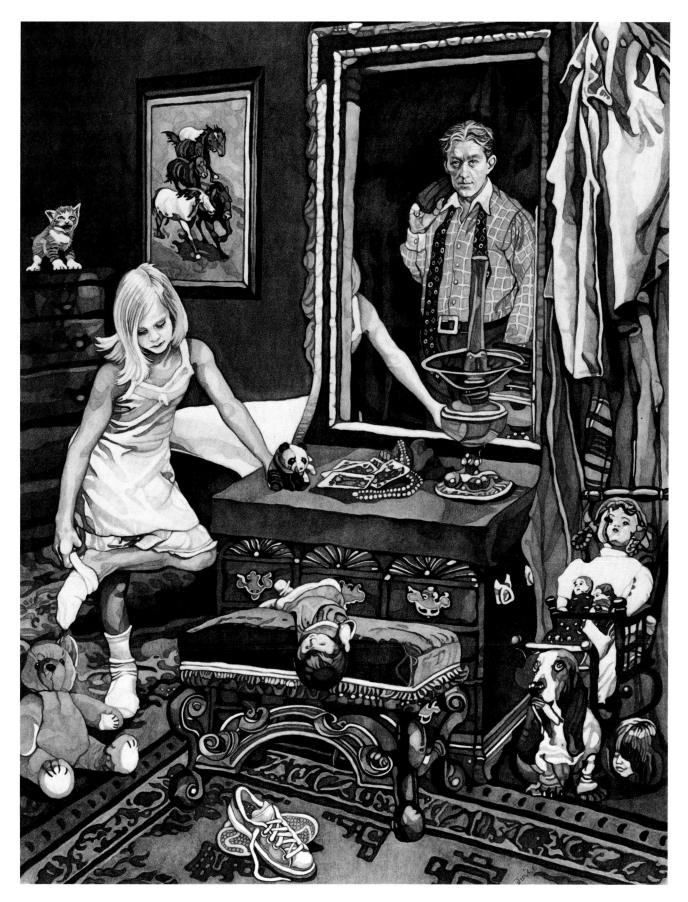

Father Love

Battered Wives

*A gentleman is one who never
strikes a woman without provocation.*

H. L. Mencken

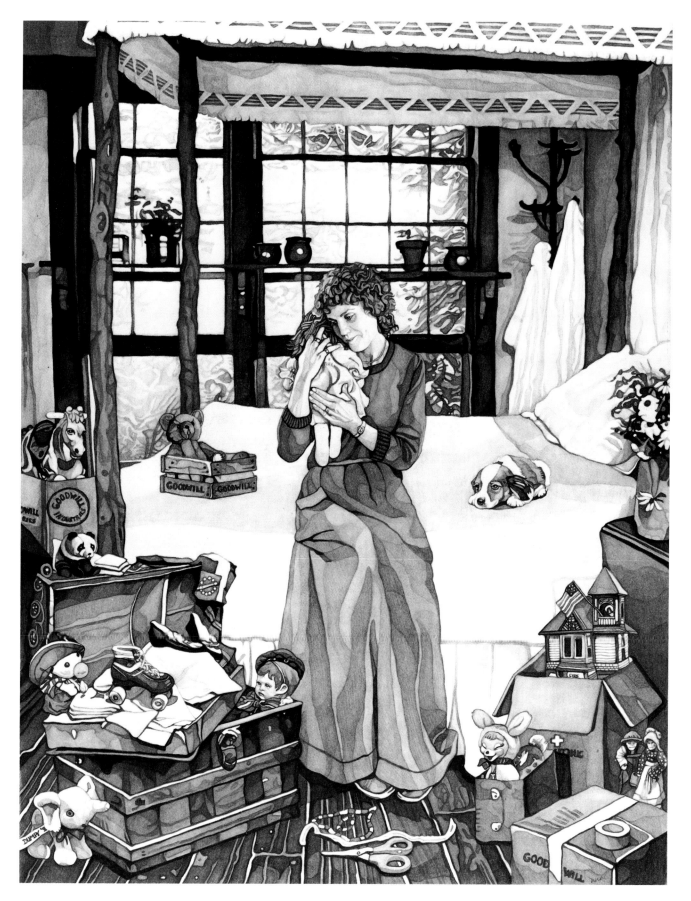

Broke

Abandoned Elderly

Let me slip away as quietly,
and as comfortably,
as I can.

Frederick Locker Lampson

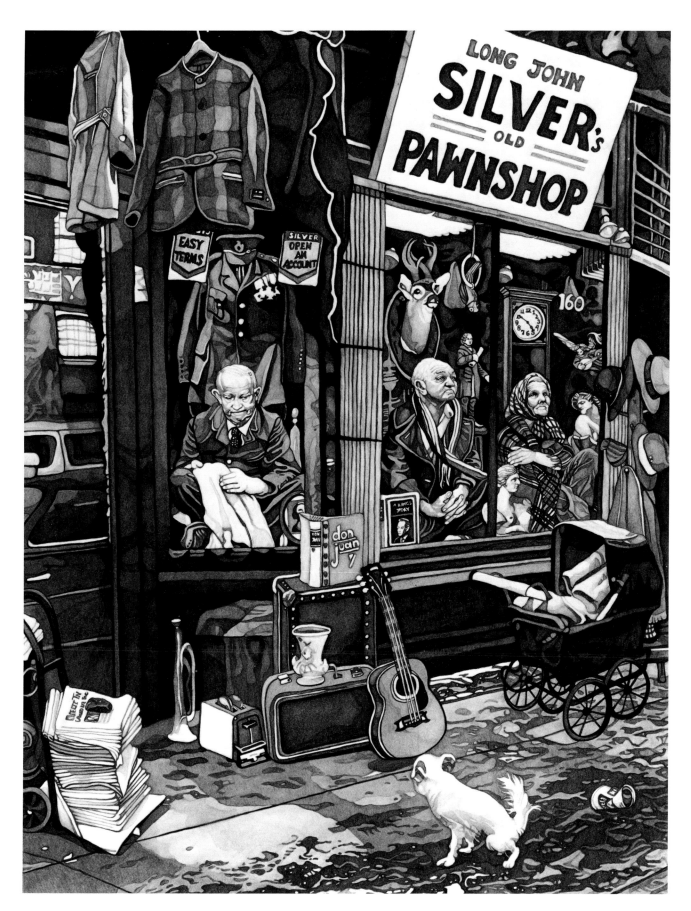

Pawned

Abandoned Elderly

Death is not the greatest loss in life.
The greatest loss is what dies . . . while we live.

Norman Cousins

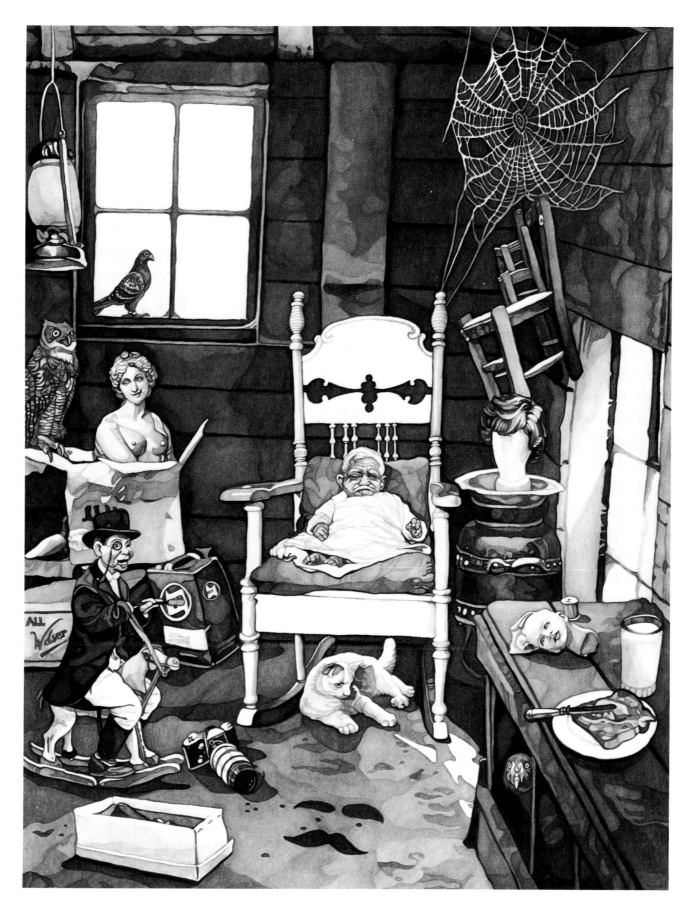

Alzheimer's

Part III

TECHNOLOGY

The Dark Side of Science

Technology

The optimist proclaims that we live in
the best of all possible worlds;
and the pessimist fears this is true.

<div align="right">James Branch Cabell</div>

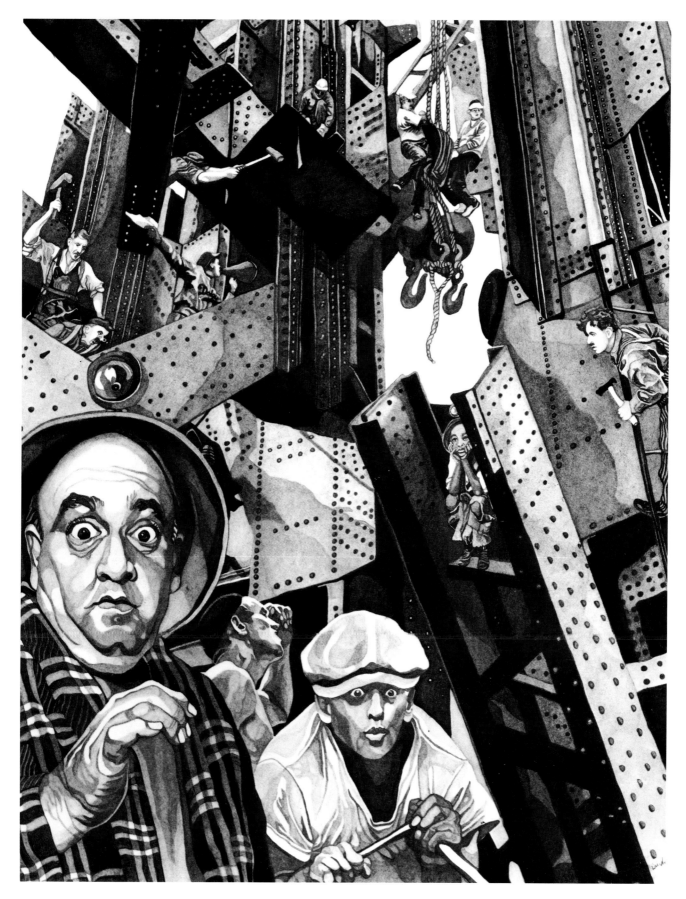

Babel

Nuclear Energy

The measure of man
is what he does with power.

Pittacus

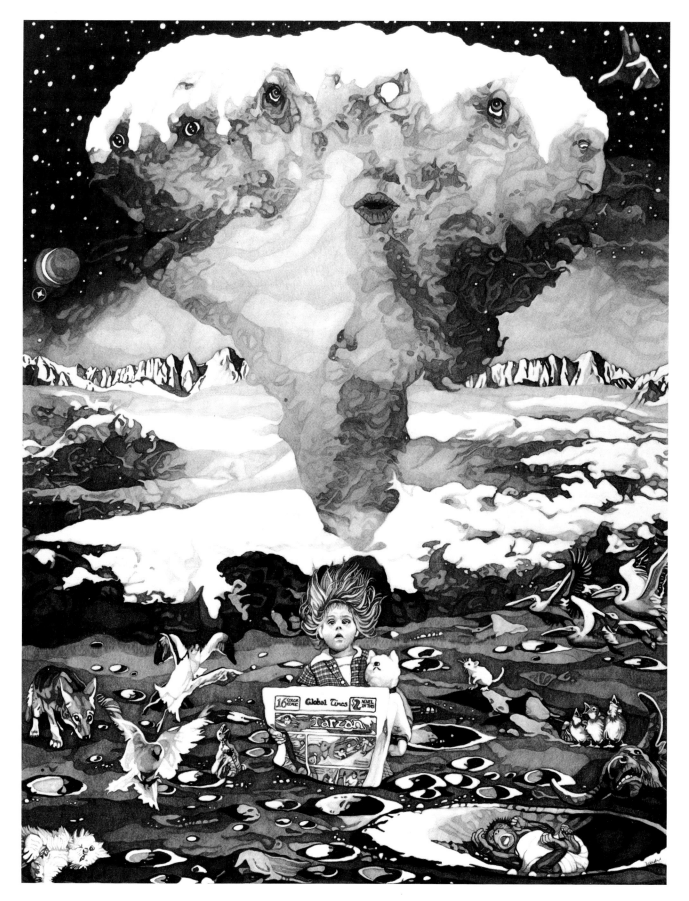

Boom Babies

Transformation of Medicine

Ever since our love for machines replaced
the love we used to have for our fellow man,
catastrophes proceed to increase.

Man Ray

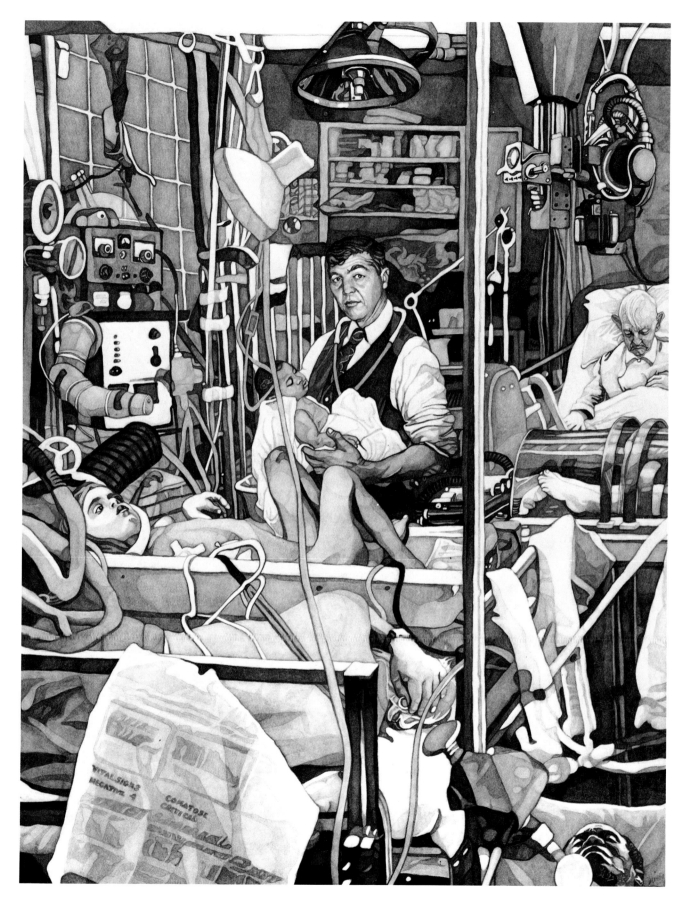

Life Support

Medical Cyborgs

This is either a forgery—
or a damned clever original!

Frank Sullivan

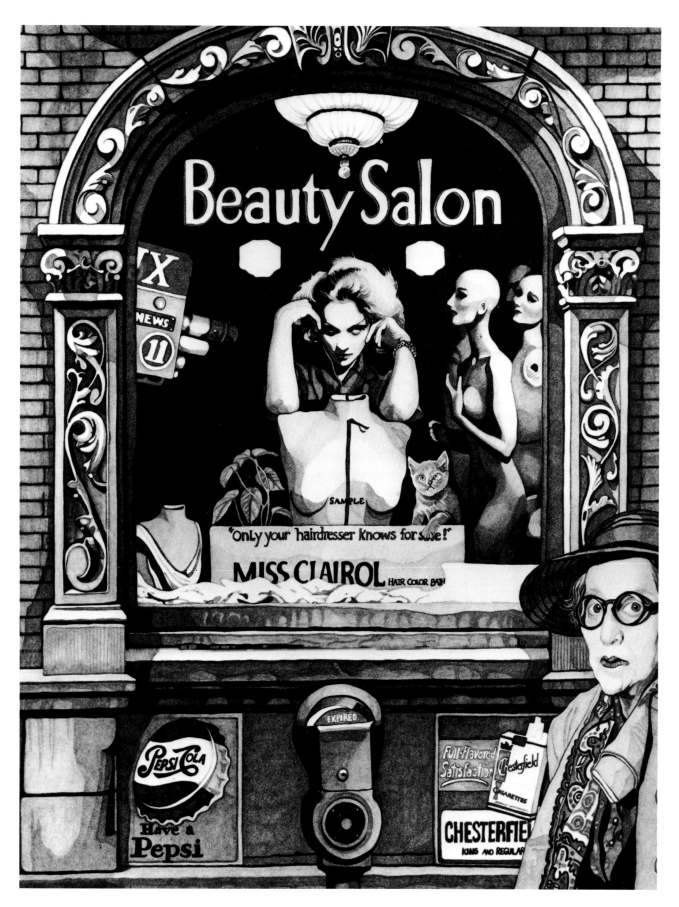

Television

Give me the children until they are seven,
and anyone may have them afterwards.

Saint Francis Xavier

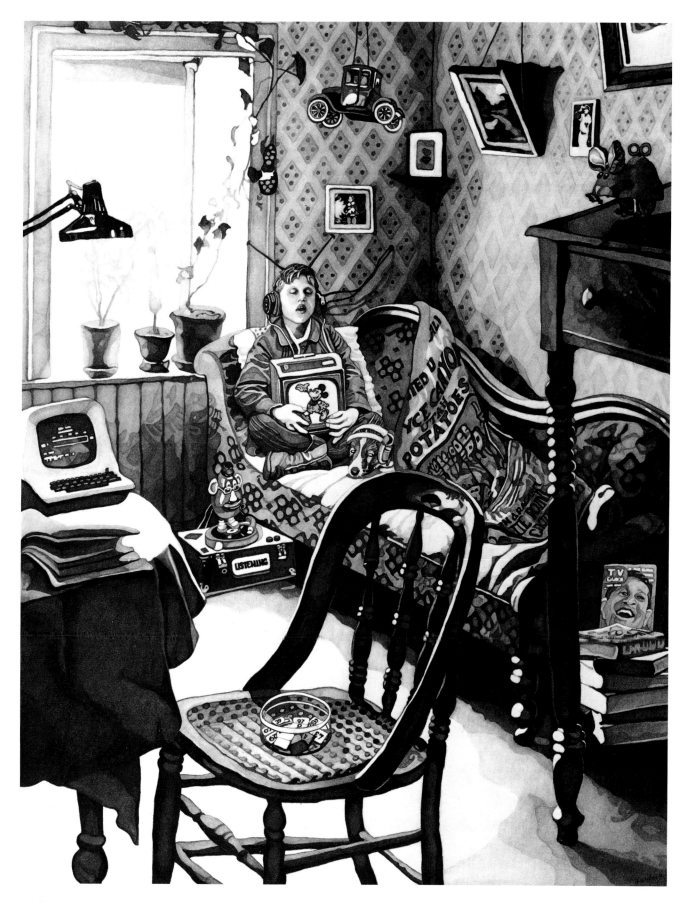

Mickey

Cybernetics

It used to be that people needed products to survive.
Now products need people to survive.

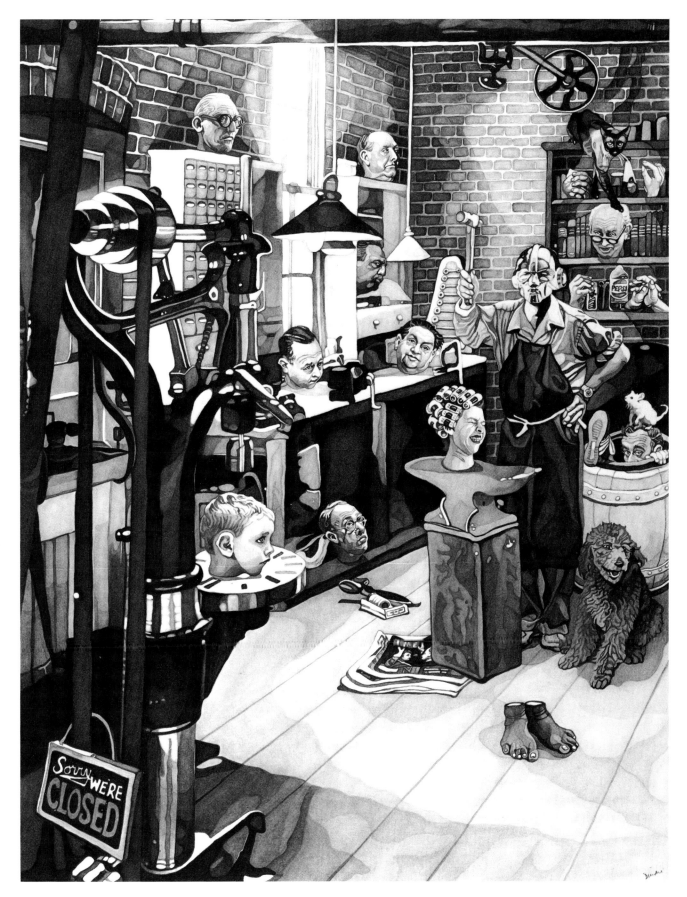

The Head Shop

Chemical/Biological Warfare

*What the scientists have in their briefcases
is terrifying.*

Nikita Krushchev

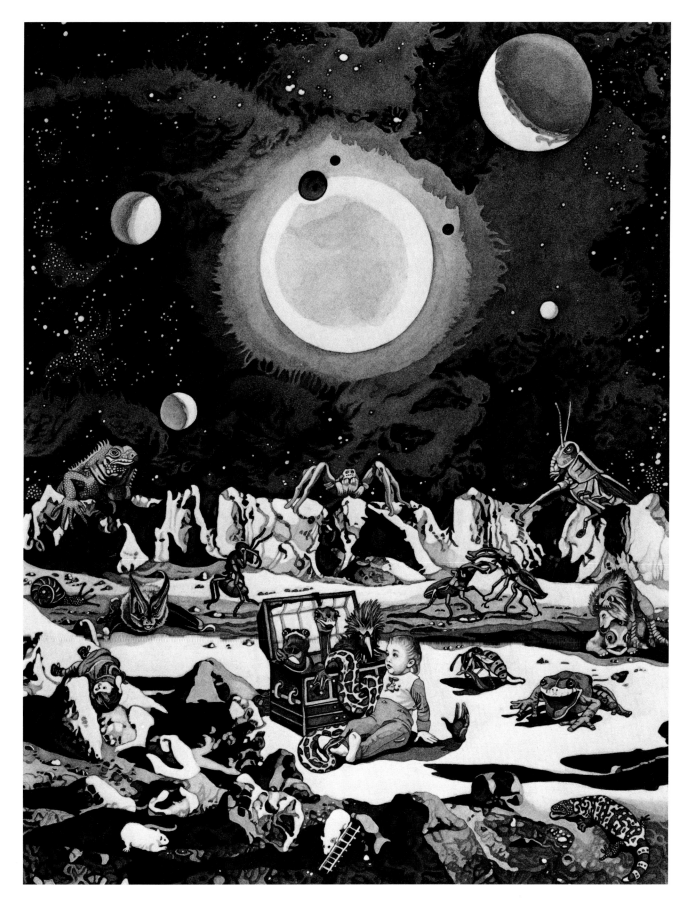

Pandora

Robotics

The danger of the past was that
men became slaves.
The danger of the future is that
Man may become robots.

Erich Fromm

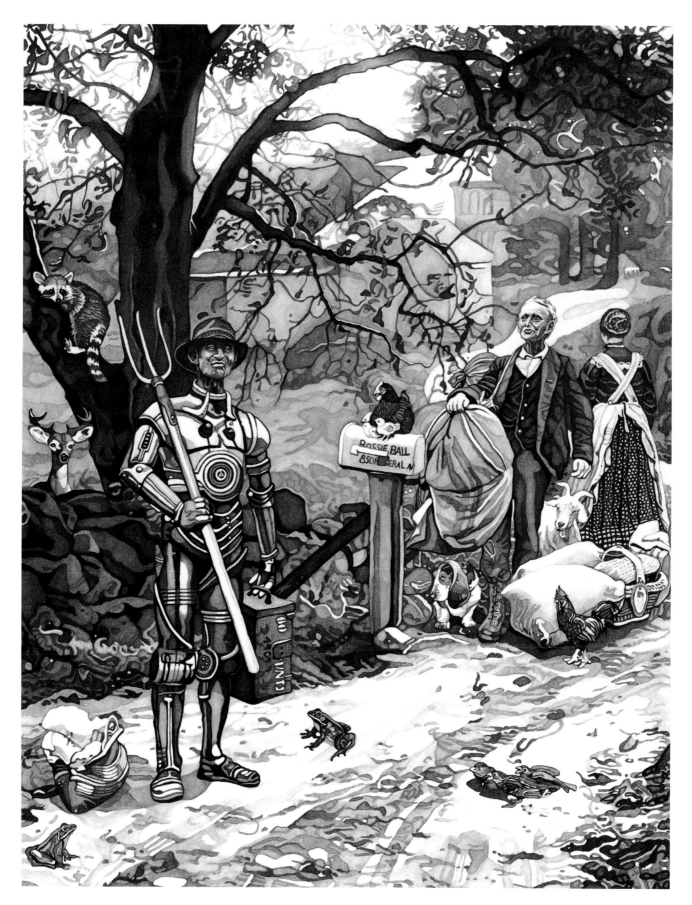

Replacements

Genetic Engineering

*Knowledge is ruin
to my young men.*

Adolf Hitler

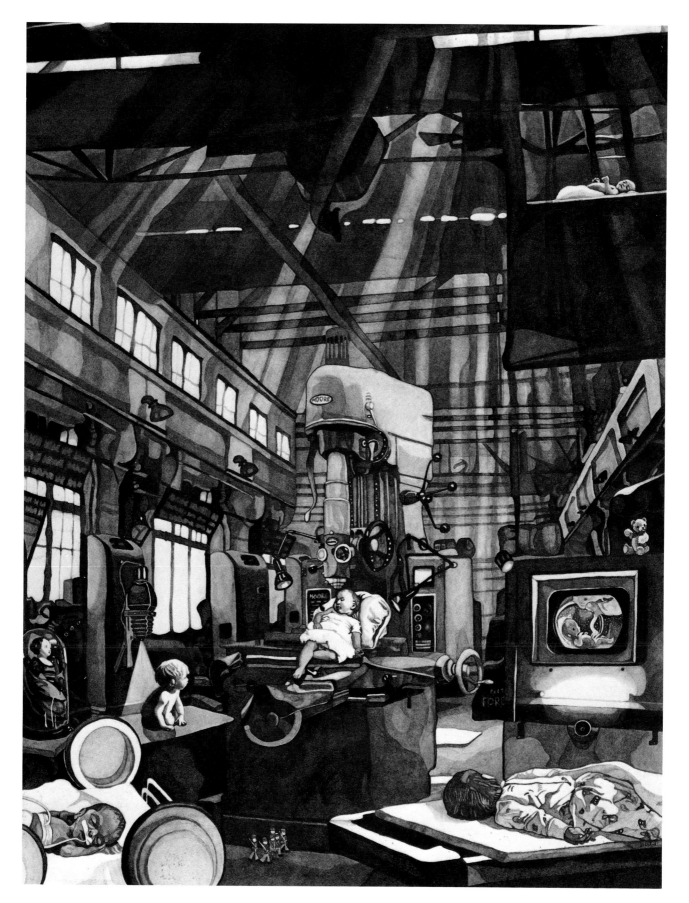

The Babies

Genetic Engineering

The only thing we have to fear on the planet is man.

<div style="text-align: right">Carl Jung</div>

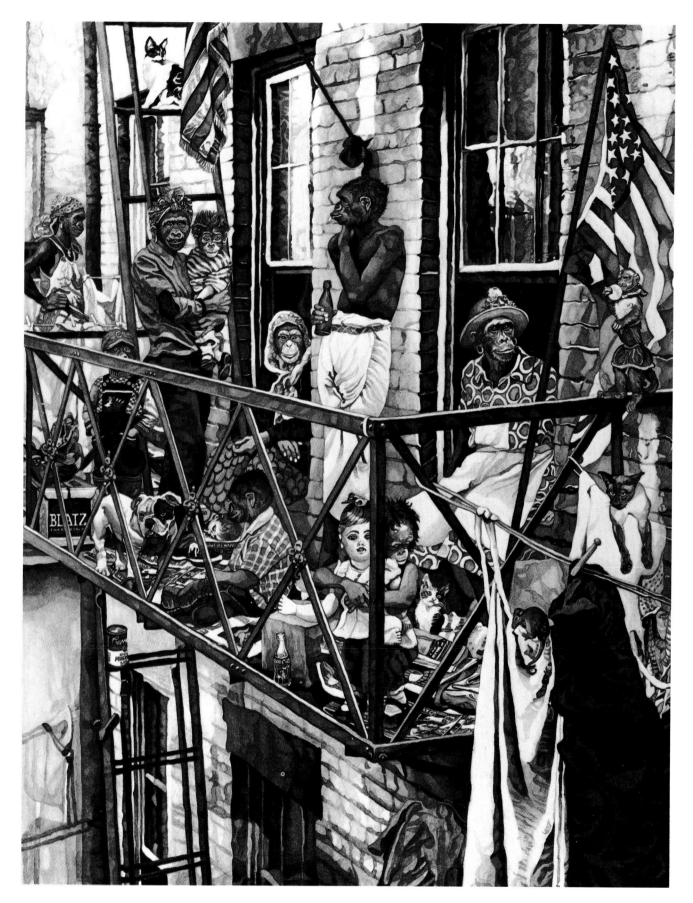

D-Evolution

Advanced Weaponry

You can't say that civilization don't advance, for in every war they kill you in a new way.

Will Rogers

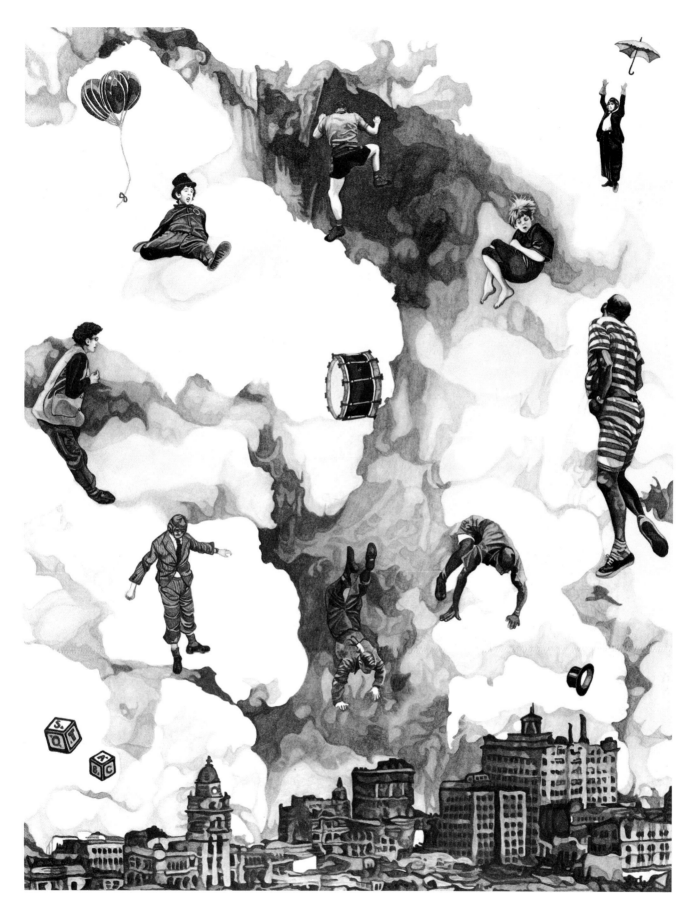

Neutrons

Part IV

ALIENATION

The Destruction of Social Being

Alienation

Humankind cannot bear very much reality.

T. S. Eliot

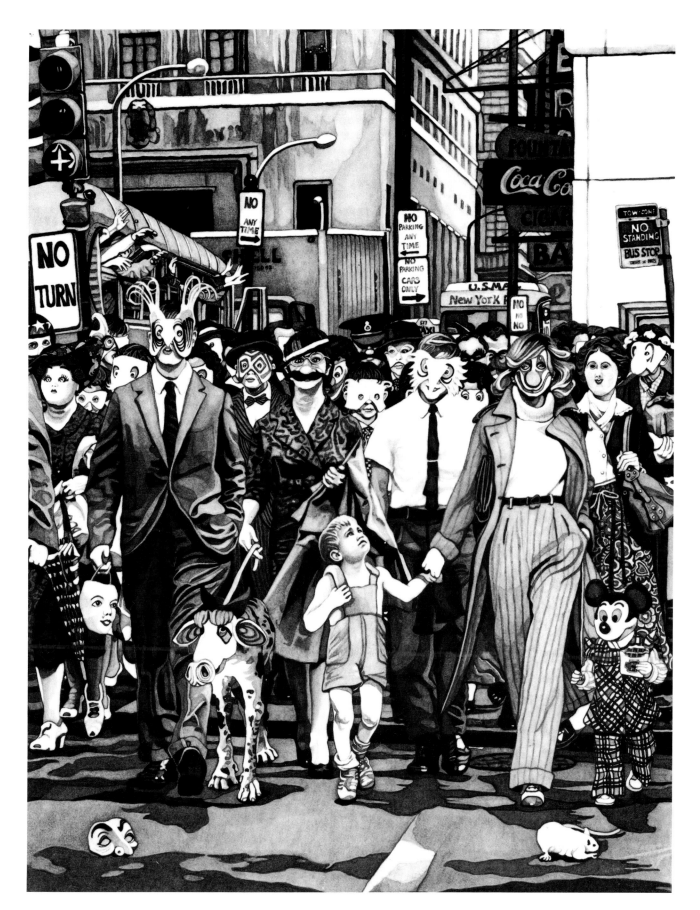

Parade

Suicide

*The question has arisen in modern man's mind
. . . whether life is worth living.*

Erich Fromm

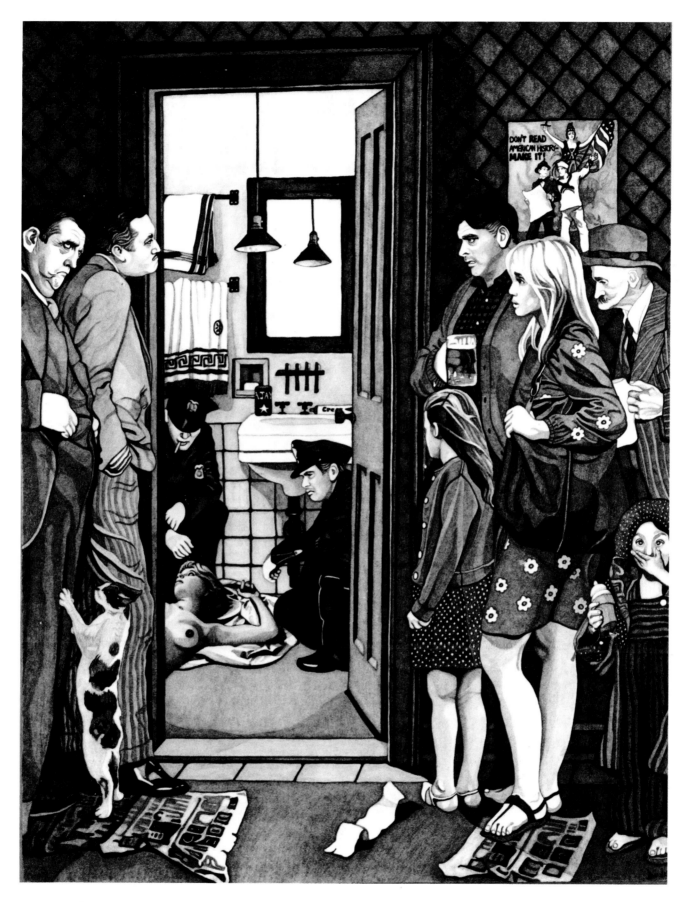

Emperor of Ice Cream

The Depersonalized Urban

Our concern is not how to worship in the catacombs,
but how to remain human in the skyscrapers.

Abraham Joshua Heschel

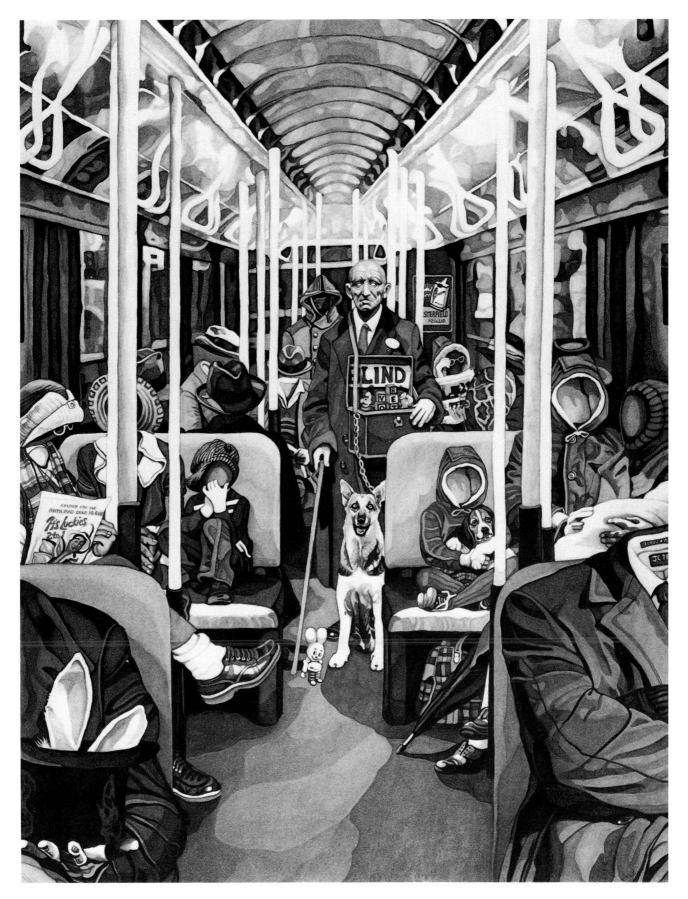

The Oracle

Drug Abuse

Happiness is the interval between periods of unhappiness.

Don Marquis

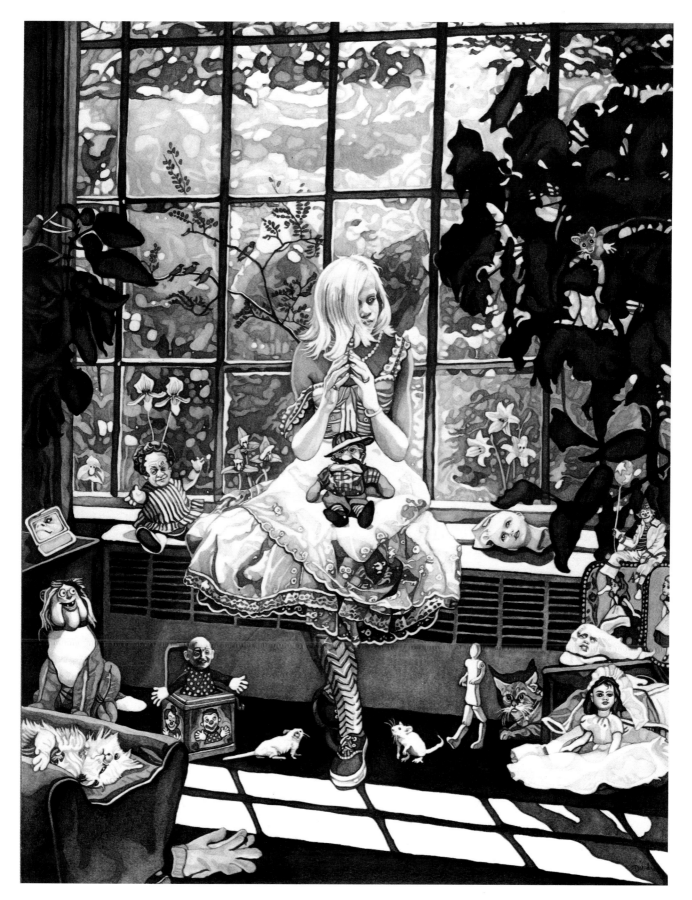

Racism

The worst sin toward our fellow creatures
is not to hate them—
but to be indifferent to them.

George Bernard Shaw

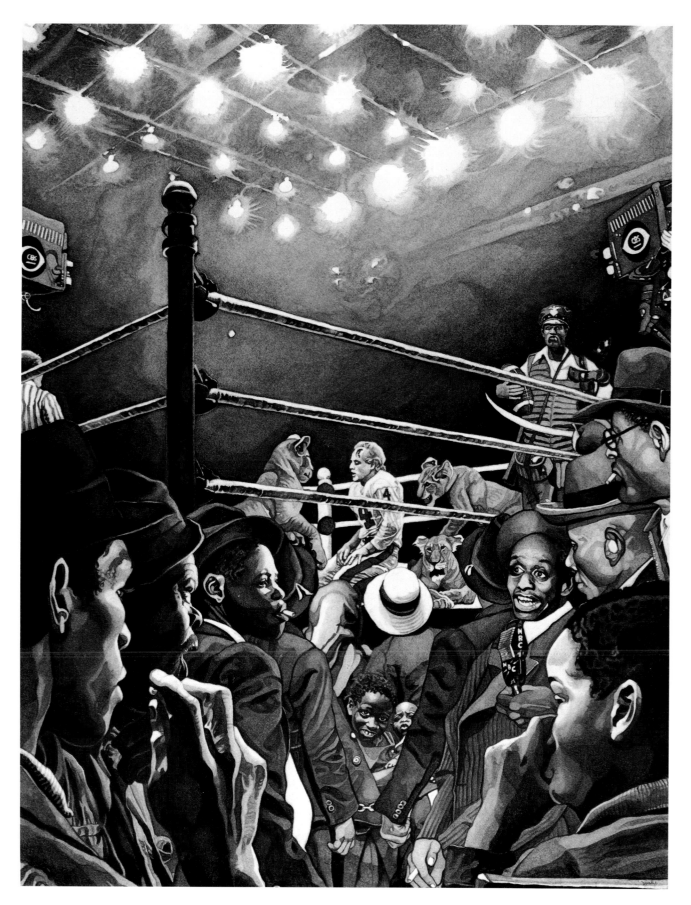

Game

Criminal Streets

You can get further with a kind word
—and a gun—
than you can with a kind word alone.

Al Capone

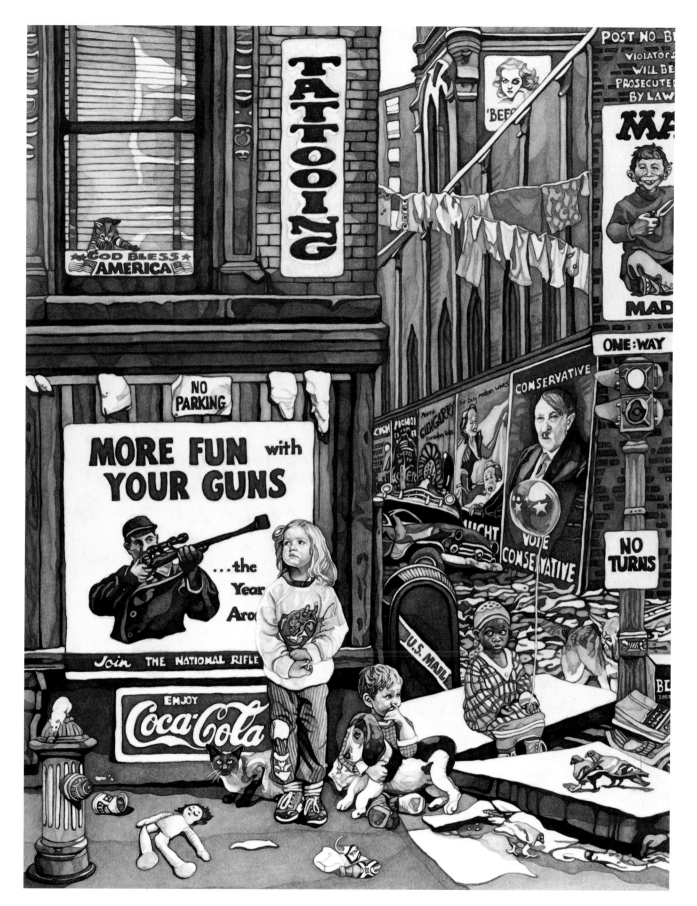

Rape

A woman reading **Playboy** *feels a little like*
a Jew reading a Nazi manual.

<div style="text-align: right;">Gloria Steinem</div>

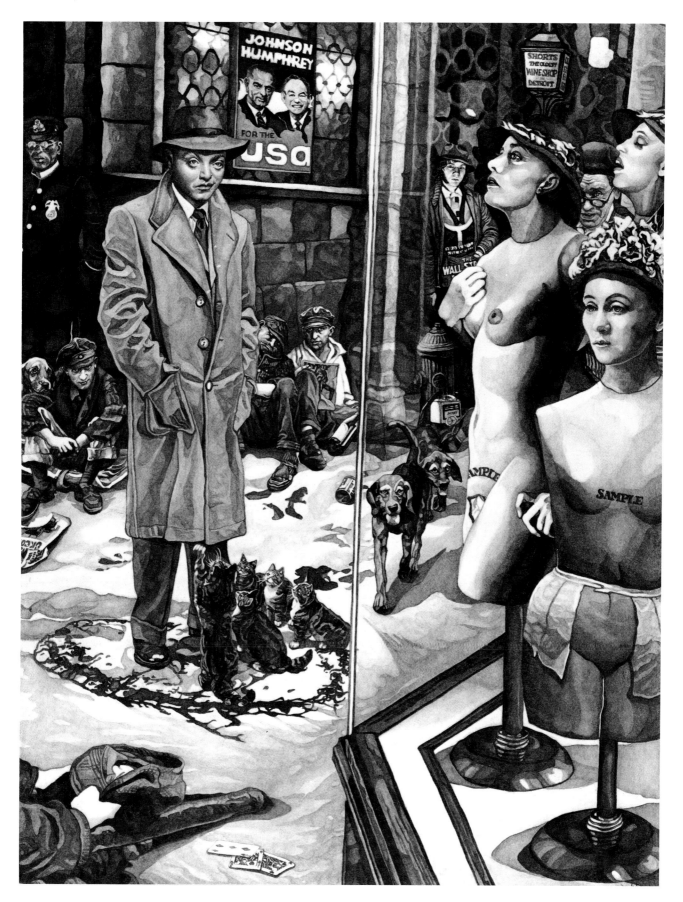

Violation

Greed

*The only thing I like about rich people
is their money.*

Lady Astor

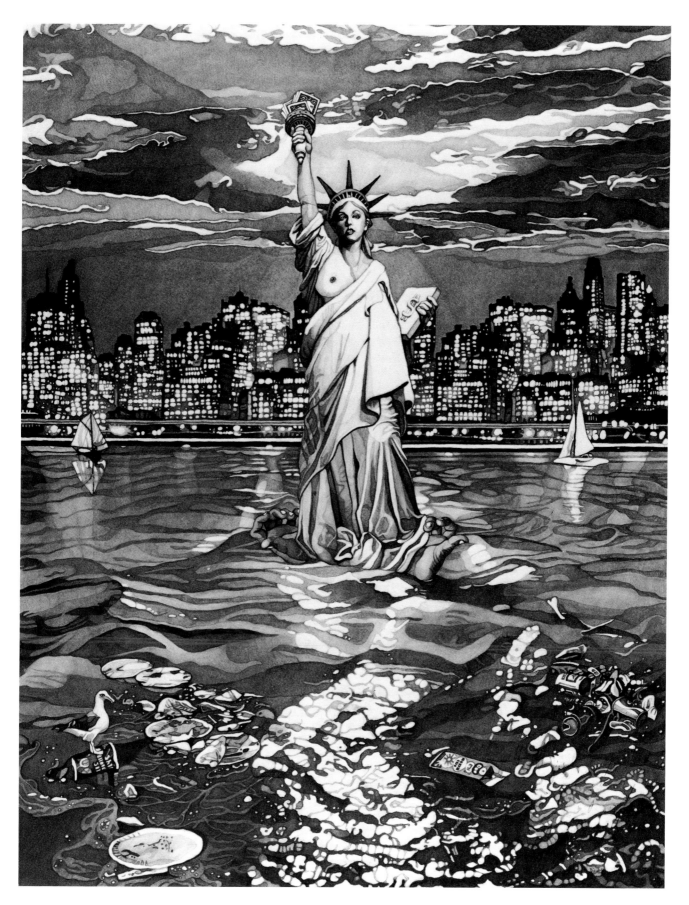

The Lady

Poverty

When an individual is kept in a situation of inferiority,
the fact is that he does become inferior.

Simone de Beauvoir

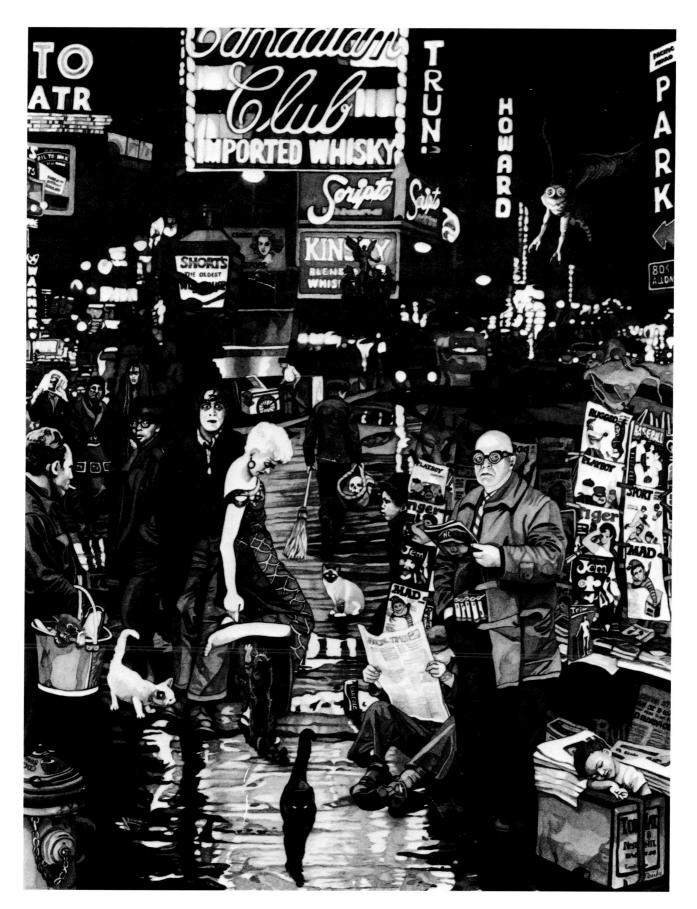

Nite Creatures

Sexual Inversion

The only abnormality
is the incapacity to love.

Anaïs Nin

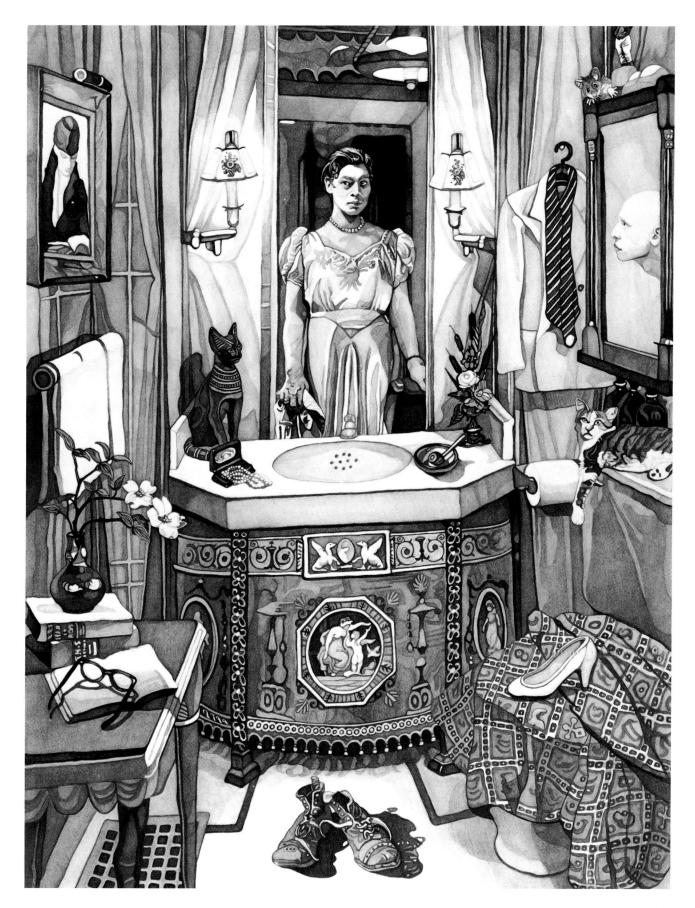

Janus

Pornography

The more humanity advances,
the more it is degraded.

Gustave Flaubert

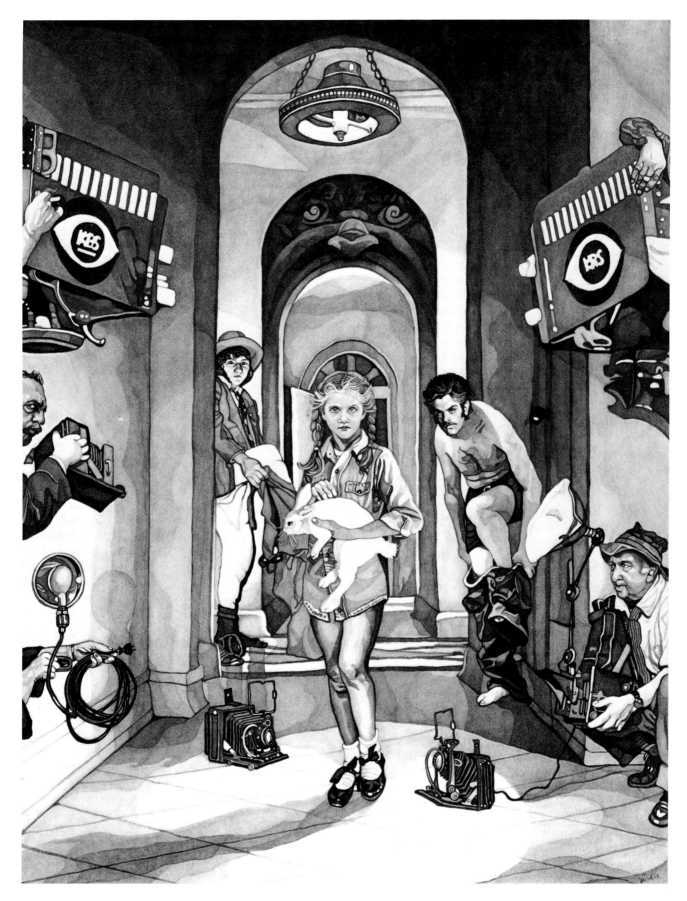

Mental Illness

The fear of life
is the favorite disease
of the twentieth century.

William Lynon Phelps

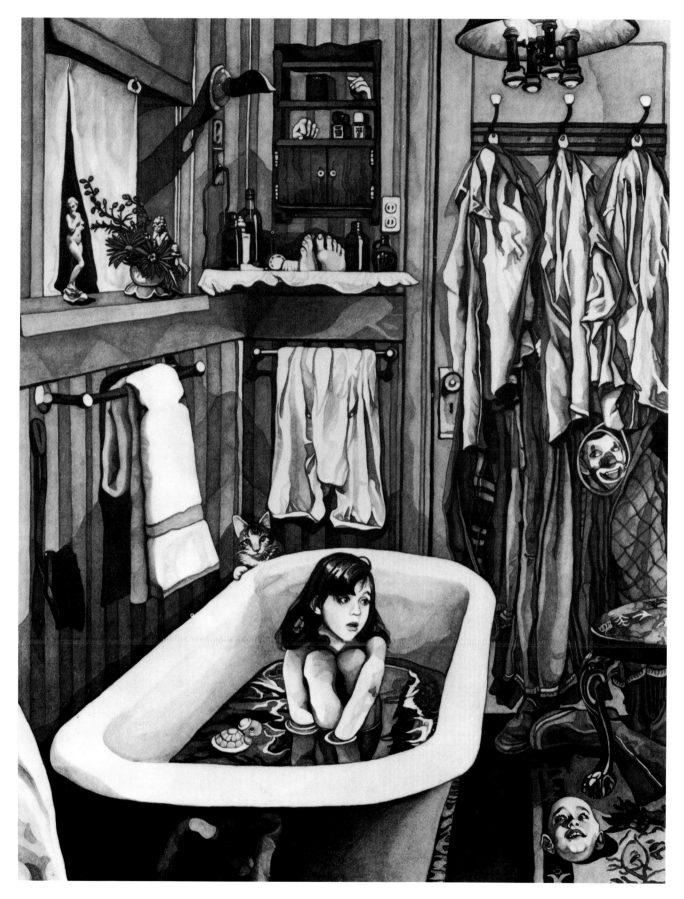

Paranoia

Alcoholism

I drink
to make other people interesting.

George Jean Nathan

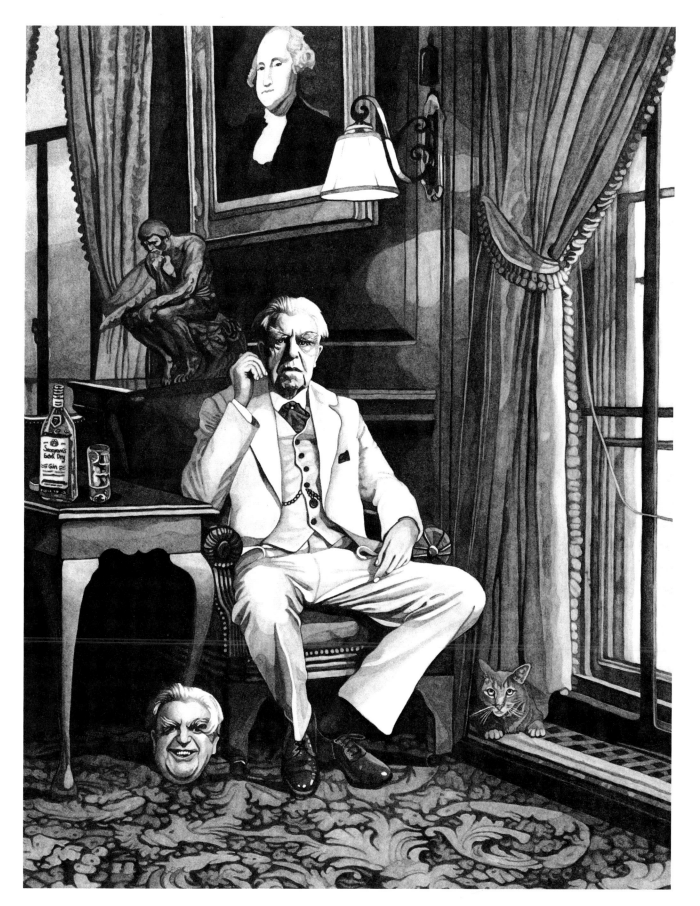

The Governor

HIV Epidemic

Am I my brother's keeper?

Genesis 4:9

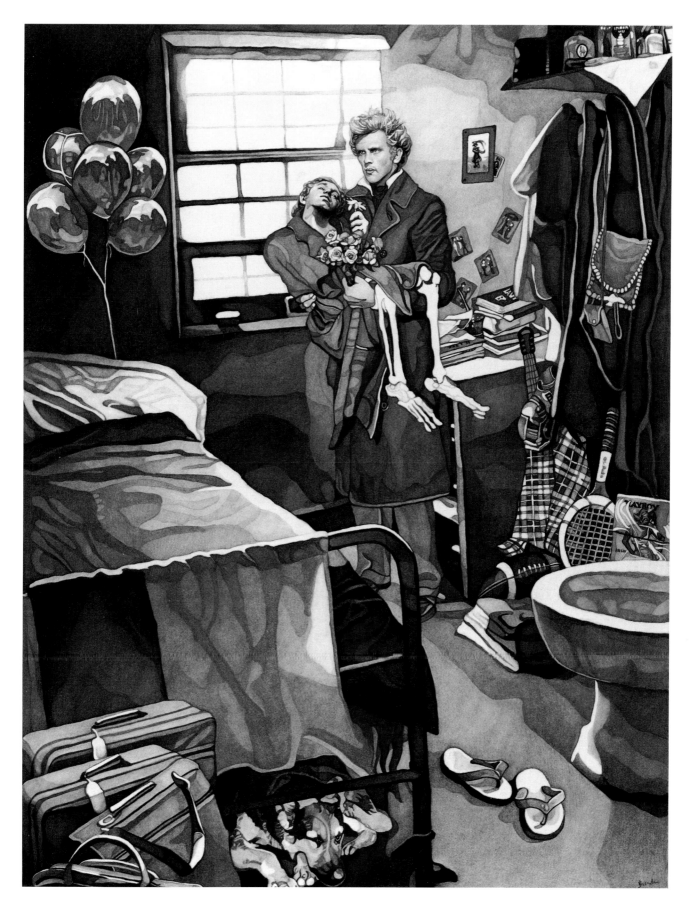

Religion: The Explosion of Tradition

*For several years more, I maintained public
relations with the Almighty;
but privately . . . I ceased to associate
with him.*

<div align="right">Jean-Paul Sartre</div>

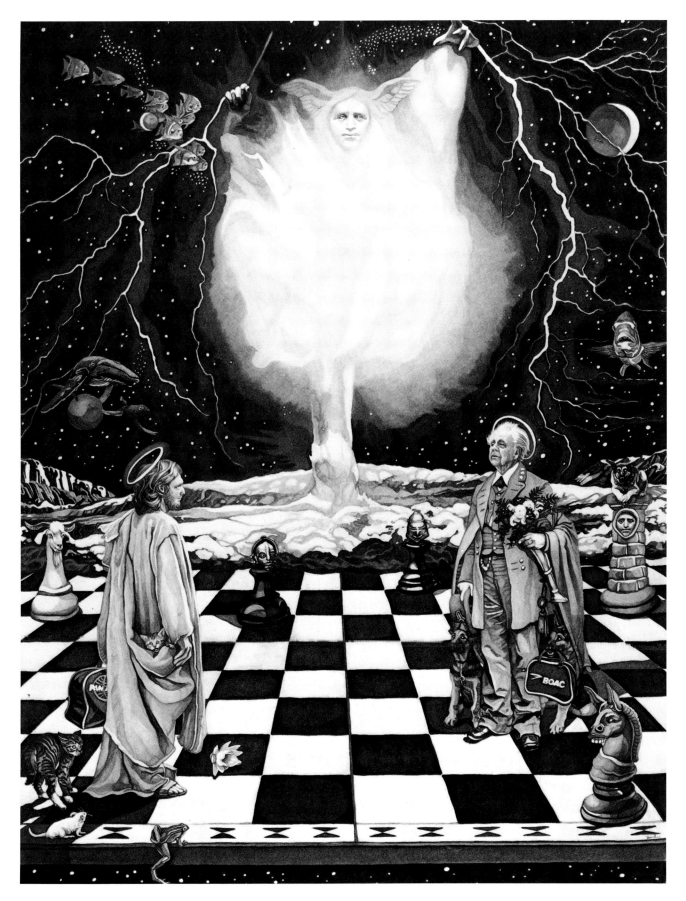

Trinity

Religion: Revival of the Cults

*The devil is a gentleman who never goes
where he is not welcome.*

John A. Lincoln

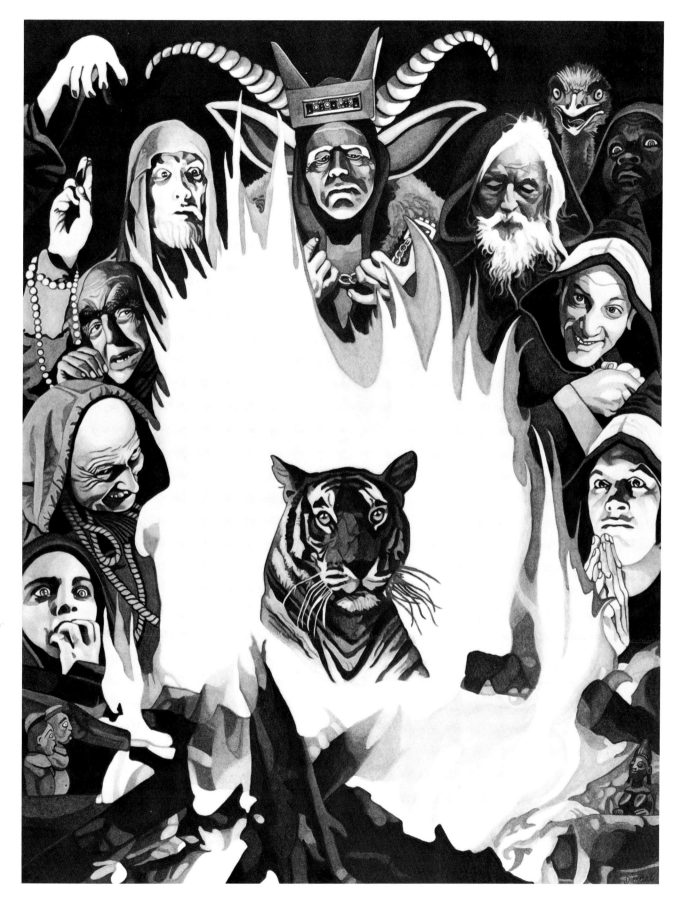

Tyger

Religion: The New Age

An era can be said to end
when its basic illusions are . . . exhausted.

Arthur Miller

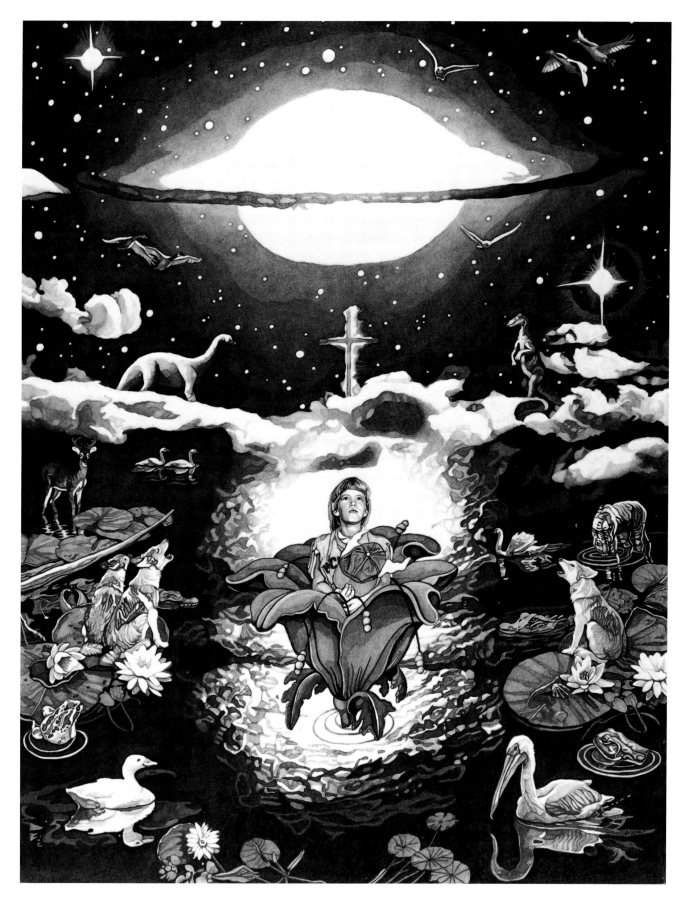

About the Artist

Born and raised in Chicago during the 1940s, graphic artist Dierdre Luzwick is a self-proclaimed baby boomer and social/environmental activist.

One of four children and the daughter of an Illinois magistrate and charismatic Irish teacher, Luzwick's early interests centered around the classics and comparative religion. Her intent was to acquire a degree in philosophy from Ripon College in Wisconsin. Instead, she left college in her second year and began drawing as a form of relaxation therapy. But her skill in visually and satirically portraying statements on the human condition quickly became evident.

Largely self-taught, Luzwick perfected her individualistic "prose art" technique and has been drawing exclusively—as a profession—for the past twenty-five years. She credits much of the message impact within her art to her years in a former marriage to a musician and their life in the slum environs of Chicago, which she says ". . . was the most profound education I could have received in the humanities."

The artist presently lives in Cambridge, a small town in rural Wisconsin, whose townsfolk have—at one time or another—been models for the distinctive characters in her humanistic portraits.

Highly detailed surrealistic images of vision and power define Luzwick's style. And her medium of choice continues to be black and white charcoal drawn on an 18 × 24 canvas format.*

Luzwick's first book, *The Surrealist's Bible,* was a collection of sixty drawings interpreting the Old Testament stories with a contemporary focus. Published by Jonathan David Publishing in New York, it was subsequently reprinted in Israel by Tammuz Publishing. She is currently working on a new series depicting a present-day view of the Scriptures entitled *Christ-Kin: The Nuclear Bible.*

The majority of her works are either in private collections or on exhibit in museums and galleries. Luzwick is a member of Wisconsin Women in the Arts League, and her drawings continue to receive praise for their craftsmanship and social relevance in outstanding reviews by major newspapers and magazines across the country.

*Full-sized 18 × 24 prints can be ordered for $25 by writing directly to the artist at W. 9338 Ripley, Cambridge, Wisconsin 53523.

Reference Reading

Michael Allaby and Floyd Allen, *Robots Behind the Plow* (Emmaus, PA: Rodale Press, 1974).

Rachel Andres and James R. Dane, *Cults and Consequences* (Los Angeles: Jewish Federation Council, 1988).

David Bender and Bruno Leone, *The Homeless: Opposing Viewpoints* (San Diego: Greenhaven Press, 1990).

Timothy Beneke, *Men on Rape* (New York: St. Martin's Press, 1982).

David Brower, *For Earth's Sake* (Layton, Utah: Gibbs Smith Publishing, 1990).

Russell Chandler, *Religious Change in America* (Irving, TX: Word, Inc., 1988).

Thomas B. Cochran, William M. Arkin, and Milton M. Hoenig, *Nuclear Weapons Databook, Vol. I* (New York: Ballinger Publishing, 1987).

Sidney Ditzion, *Marriage, Morals and Sex in America* (New York: Octagon Books, 1969).

June Goodfield, *Playing God* (New York: Random House, 1977).

Cheryl Gorder, *Homeless: Without Addresses in America* (Tempe, AZ: Blue Bird Publishing, 1988).

Carol Gorman, *Pornography* (New York: Random House, 1977).

Robert Gottlieb, *A Life of Its Own* (Orlando, FL: Harcourt Brace Jovanovich, 1988).

Andrew M. Greeley, *Religious Change in America* (Cambridge, MA: Harvard Univ. Press, 1989).

Brent Q. Hafen, *Youth Suicide* (Evergreen, CO: Cordillera Press, 1986).

Robert Hamrin, *America's New Economy: The Basic Guide* (New York: Franklin Watts, 1988).

Gordon Hawkins and Franklin E. Zimring, *Pornography in a Free Society* (New York: Cambridge Univ. Press, 1988).

Shere Hite, *The Hite Report* (New York: Dell Publishing, 1976).

Morton Hunt and Bernie Hunt, *The Divorce Experience* (New York: McGraw-Hill, 1977).

Austin Kiplinger and Knight Kiplinger, *America in the Global '90s* (Washington, D.C.: The Kiplinger Letter, 1989).

Stanley, Krippner, *Human Possibilities* (Garden City, NY: Anchor Press/Doubleday, 1980).

Arthur Lyons, *Satan Wants You* (New York: The Mysterious Press, 1988).

Jeanne McDermott, *The Killing Winds* (New York: Arbor House, 1987).

Robert S. McNamara, *The Population Problem: Time Bomb or Myth* (Washington, D.C.: Population Reference Bureau, July 1, 1984, speech).

Thomas H. Metos. *Artificial Humans* (New York: Julian Messner/Simon & Schuster, 1985).

Marvin Minsky, *Robotics* (Garden City, NY: Omni Press—Anchor/Doubleday, 1985).

National Wildlife Federation, *Global Warming: A Personal Guide to Action* (Washington, D.C.: National Wildlife Federation, 1989).

———, *The Greenhouse Debate* (Washington, D.C.: National Wildlife Federation, 1989).

Jane O'Reilly, *The Girl I Left Behind* (New York: Macmillan Publishing Company, 1980).

PETA, *People for the Ethical Treatment of Animals* (Washington, D.C., PETA, 1990).

Pharos Books, eds., *The World Almanac 1990* (New York: Scripps Howard).

Charles Piller and Keith R. Yamamoto, *Gene Wars* (New York: William Morrow, 1988).

Tom Regan, *The Struggle for Animal Rights* (Clarks Summit, PA: International Society for Animal Rights).

Jim E. Reilly, *The Cold War Is Getting Hotter* (Tucson, AZ: World University Roundtable).

Jeremy Rifkin, *Entropy: A New World View* (New York: Bantam, 1989).

———, *Declaration of a Heretic* (New York: Routledge Chapman and Hall, 1985).

———, *Green Lifestyle Guide* (New York: Henry Holt and Company, 1990).

Alice M. Rivlin and Joshua M. Wiener, *Caring for the Disabled Elderly* (Washington, D.C.: Brookings Institution, 1988).

Wade Clark Roof and William McKinney, *American Mainline Religion: Its Changing Shape and Future* (New Brunswick, NJ: Rutgers Univ. Press, 1987).

Peter H. Rossi, *Down and Out in America* (Chicago: University of Chicago Press, 1984).

Stephen Schneider, *Global Warming* (San Francisco: Sierra Club Books, 1989).

Sunbear, *Black Dawn* (Santa Fe, NM: Bear Tribe Press, 1991).

Karen Swisher, ed., *The Elderly: Opposing Viewpoints* (San Diego: Greenhaven Press, 1990).

United Nations Environmental Program, *State of the World* (Washington, D.C.: United Nations Environmental Program, 1989).

Robert Wuthrow, *The Restructuring of America* (Princeton, NJ: Princeton Univ. Press, 1988).

Endangered Species: Portraits of a Dying Millennium was set in
Meridien and Gill Sans by Wilsted & Taylor, Oakland, California.
The illustrations were printed as black and gray duotones on Lustro Gloss paper.
Designed at Harper San Francisco by Abby Zimberg.
Printed and bound by Arcata Graphics, Kingsport, Tennessee.